First published in 2006 by
The Ogden Museum of Southern Art
University of New Orleans

925 Camp Street
New Orleans, LA 70130, USA
www.ogdenmuseum.org
504.539.9600

Published in conjunction with the exhibition
Art and Life in Louisiana: Elemore Morgan Sr. & Elemore Morgan Jr.
April 1, 2006 – July 30, 2006

ISBN 0 9772544 1 0

Library of Congress Cataloguing-in-Publication Data available upon request

Foreword by J. Richard Gruber, Ph.D.
Written by David Houston
Photography by Hunter Clarkson, ALTLEE Photography
Designed by Phillip Collier and Dean Cavalier of the Phillip Collier Studio
Printed by Garrity Printing

Back cover: All images by Elemore Morgan Sr. and Elemore Morgan Jr.

ART AND LIFE IN LOUISIANA:

ELEMORE MORGAN SR.
&
ELEMORE MORGAN JR.

David Houston

THE OGDEN MUSEUM OF SOUTHERN ART
university of new orleans

FOREWORD

The South was very different in 1943, when Elemore Morgan Sr. published his first photographs in Harnett Kane's book, *The Bayous of Louisiana*. As a native son, Morgan knew his part of the South intimately, the Acadiana region of Louisiana, marked by its unique environment and distinctive Cajun culture. And, as David Houston suggests in his insightful accompanying essay, this is what Morgan photographed, including "the vernacular churches, the plantation houses that dot the landscape along the river, and the people of Louisiana." Like all of his photographs of Louisiana, these survive as sensitive reflections, documents of a specific and changing time and place in the South, after the Great Depression and during the war years, before the post-war era brought dramatic changes to even the most remote regions of the Deep South.

Looking back, from our perspective in 2006, during the rapidly expanding digital age, it is often difficult to remember how remote and isolated parts of this state, and this region, were little more than six decades ago. And it may be equally difficult to recall that during that time the visual and literary artists of the South, even William Faulkner, struggled to achieve recognition and to make a living as an artist. Yet, as Malcolm Cowley wrote during the fall of 1945, two years after the publication of *The Bayous of Louisiana*, it was "a time when Faulkner's books were little read and often disparaged. He had a few enthusiastic defenders, but no one, so it seemed to me then, had more distantly suggested the scope and force and interdependence of his work as a whole."

Despite this lack of recognition, as Cowley observed, Faulkner continued to write, building an "interconnected pattern" in his writing, one that was "based upon what he saw in Oxford or remembered from his childhood; on scraps of family tradition…on kitchen dialogues between the black cook and her amiable husband; on Saturday-afternoon gossip in Courthouse Square; on stories told by men in overalls squatting on their heels while they passed around a fruit jar full of white corn liquor; on all the sources familiar to a small-town Mississippi boy." Most significantly, as Cowley concludes, Faulkner created an entire world, one built upon his experiences and understanding, as well as his vision, of the American South. "There in Oxford, Faulkner performed a labor of imagination that has not been equaled in our time, and a double labor: first, to invent a Mississippi county that was like a mythical kingdom, but was complete and living in all its details; second, to make his story of Yoknapatawpha County stand as a parable or legend of all the Deep South." [1]

In their own way, in their own time and place in the Deep South, in Louisiana, Elemore Morgan Sr. and Elemore Morgan Jr. have lived and worked, it seems to this observer, on a track parallel to that of William Faulkner in Mississippi. Though immersed in the education, travel and opportunities offered to him in the post-war era, Elemore Morgan Jr. returned to the place of

his birth, where he remains, working in a studio surrounded by rice fields, not far from Abbeville, Louisiana (where his father photographed the Southern premiere of Robert Flaherty's classic film, *Louisiana Story*, in 1948). After studying at Louisiana State University (LSU) in Baton Rouge, traveling to Korea and Japan while serving in the Air Force, then studying at the Ruskin School of Art at Oxford University in England, he made the conscious choice to return home in 1957, where he has lived and worked, despite the challenges of creating a career there, ever since. In so doing, much to our good fortune, he has become one of the most important artists, and most influential art teachers, in Louisiana's art history.

This publication, accompanying a major retrospective of the works of father and son at The Ogden Museum of Southern Art, offers an overview survey of the art and history of these two important figures. The project, and the publication, were planned and directed by David Houston, Chief Curator of The Ogden Museum, who faced no small number of challenges in bringing these projects to fruition, including the scheduling and technical delays brought by the combined impacts of Hurricanes Katrina and Rita upon our city and our state. Through every step of this process, Houston has enjoyed the generous and unflagging enthusiasm and support of Elemore Morgan Jr., without whom this project would not have been possible. This is the first retrospective exhibition of this magnitude devoted to the rich and complex works of these two Louisiana artists. We are honored that The Ogden Museum of Southern Art, University of New Orleans, has served as the selected host of the project.

There are many others who should be thanked for making this project possible. One of the first is Roger Houston Ogden, whose passion for Southern art and vision for a museum of Southern art in New Orleans led to the formation of this museum, and who was a significant early collector of the works of both Elemore Morgan Sr. and Elemore Morgan Jr. The publication of this catalogue was made possible by the generous support of Nancy Link Adkerson, who has long appreciated the Louisiana vision of the Morgan family. All black and white exhibition prints, from the 4" x 5" original negatives of Elemore Morgan Sr., were created by master printer David Zietz. This exhibition catalogue was designed by Phillip Collier and Dean Cavalier, of the Phillip Collier Studio in New Orleans, and captures the distinctive spirit of these Louisiana artists. Photography was provided by Hunter Clarkson, AltLee Photography, Inc. An earlier retrospective exhibition, *Where Land Meets Sky, Paintings and Drawings by Elemore Morgan Jr.* and its accompanying catalogue, organized and presented by Bryan F. LaFaye, at the University Art Museum, University of Southwestern Louisiana, Lafayette, in 1999, served as an important foundation for much of the research associated with this project. Finally, we thank Arthur Roger of the Arthur Roger Gallery in New Orleans, for his patience and support throughout all phases of this project, and more importantly, for his early vision in advancing the recognition of the works of Elemore Morgan Jr.

J. Richard Gruber, Ph.D.
Director
The Ogden Museum of Southern Art
University of New Orleans

[1] Malcolm Cowley, "Introduction," in *The Portable Faulkner* (New York: The Viking Press, 1967), viii.

ELEMORE MORGAN SR.:
THE JOURNEY OF A PHOTOGRAPHER

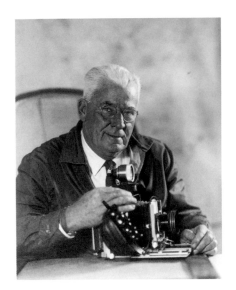

Cover story in *Register Magazine*
May 20, 1961
Photo by Elmer Nettles

The photographic career of Elemore Morgan Sr. was part pragmatism and part poetry. He began photographing in earnest in the late 1930's at the height of the Great Depression and on the eve of the Second World War. His first photographic subjects were the vernacular churches, the plantation houses that dot the landscape along the river, and the people of Louisiana. Over the next two and a half decades Morgan would increasingly be recognized for his extraordinary insight into the people and places of Louisiana during a period of accelerated change. Morgan published his first work in Harnett Kane's 1943 book, *The Bayous of Louisiana*, and publishing remained important to his work throughout his life. By the end of the war, Morgan was working full time as a photographer. He continued to explore the subjects that had preoccupied his early years, while also documenting the many changes in the region brought by the modernization of rural Louisiana. This unusual characteristic of simultaneously looking back at the region's history and looking forward to the unfolding of historical change was a distinctive trait of Morgan's photographic vision. Morgan followed this inner-directed course of simultaneously embracing the richness of Louisiana's cultural inheritance and the unfolding of the progressive era of the post-war years for the rest of his career, a career that spanned a quarter of a century of unprecedented historical change.

Elemore Morgan Sr.'s path to becoming a full-time photographer was not easy. His youthful dream was to become an architect, and to that end, he briefly attended Louisiana State University. During his time at Louisiana State University (LSU) he furthered his interest in architectural drafting and gained valuable architectural experience, but was ultimately forced to withdraw and find a full-time job because of financial restraints. Morgan worked at a variety of jobs including sales, construction work, and architectural drafting before becoming the manager of the B.F. Goodrich Tire Agency in Baton Rouge, Louisiana in 1926. In 1927 he married Dorothy Golden, a native of Abbeville, Louisiana, and four years later, their only son, Elemore Morgan Jr. was born. In 1931 Morgan became the manager of the Pan American Petroleum Company in Baton Rouge. If not for the difficult climate created by the Depression and a debilitating illness, Morgan's life course might have been set in the early 1930's. A serious lung ailment, most likely tuberculosis, forced him to resign his job and recuperate at home for a couple of years, followed by one year in a Texas sanatorium. His recovery was a four-year ordeal, and by 1936 he was back in Louisiana working as a construction supervisor with the A. Hays Town and N.W. Overstreet architectural firm in Lafayette. Three years later Town opened his own practice in Baton Rouge, and Elemore Morgan Sr. became a full partner in the new firm. This partnership would last until 1942, when the deprivations caused by the war brought an abrupt end to new construction projects across the country. Morgan began farming the family land south of Baton Rouge and increasingly concentrated on photography as both a personal investigation and a professional pursuit. At the end of the war he set aside farming and dedicated himself to photography full time.

Morgan bought his first camera, a folding Kodak 122 in 1927. He photographed sporadically until working with the Town and Overstreet architectural firm, where he regularly photographed projects during construction and after completion. During his long recuperation from tuberculosis, Morgan had begun to paint and draw. While these early works clearly indicate a natural talent for drawing and an innate sense of composition, it is clear that photography was his chosen medium. Morgan's photographic works from the late 1930s and early 1940s are consistent with the regionalist impulse that was sweeping American culture in the decade before World War II. His images of rural churches, decaying plantation homes, Cajun cottages, and humble shacks all speak of a remote corner of America that was far from the popular imagination. Morgan's architectural training and construction experience made him particularly sensitive to the nuances of vernacular architecture that he saw as symbolic of a vanishing world in transition. Many of his most striking images were shot as an amateur feeling his way into the profession of photography. These images are simple and direct, and still evoke a time radically different than our own accelerated world. Morgan looked at the world around him without the sentimentality of nostalgia or the blind belief in a utopian progress. This simultaneous interest in the past and the future marked his mature work for the rest of his life.

In the mid-20th century the major arena for photography was journalistic magazines such as *Life* and *Look* that were dominated by the photojournalist technique of reportage. Photographers traveled on assignment, producing large bodies of work from which the magazine would choose images to constitute a visual narrative for the story. This formula produced some of the great photographs and photographers of the 20th century. Although it is often the model against which he is measured, it could not be further from the working mold embraced by Morgan. Cartier-Bresson once wrote that the successful photographer of reportage cannot merely be a globetrotting tourist with a camera, but must find a deeper connection to the subject. Morgan was a man whose hands and feet were both figuratively and literally rooted in the soil of Louisiana. His was the perspective of an insider. While his photographs were documentary and often narrative in purpose, his work is opposed to the tradition of reportage characterized by the outsider's momentary objective glance—a glance that often seeks drama, exoticism and coherent sequences of photographs. The photojournalist's art was facilitated by the development of the 35mm camera, which was light, portable, discreet, and could shoot a great number of exposures before reloading. Morgan's 4"x 5" cameras demanded slow, deliberate working habits. Many of his photographs were taken from a porthole in the roof of a modified Studebaker automobile, which also included a rear-mounted icebox for keeping film cool in the hot Louisiana climate. On occasion he would handhold his 4"x 5" cameras, but most of his photos were taken more deliberately using a camera support. Like many photographers of his generation he was slow to adopt the 35mm camera as a working tool. He began using a Topcon 35mm during the last three years of his life and delighted in the speed, directness and clear accurate view of his subject that had attracted others to the smaller camera.

Oakhurst, home of Dr. and Mrs. L. E. Morgan, parents of Elemore Morgan Sr.

Office, darkroom and studio of Elemore Morgan Sr.
(circa 1960). Photo by Elemore Morgan Sr.

Morgan was largely self-taught as a photographer. He readily sought the advice of other photographers, and his friendships with Fonville Winans, Todd Webb and Ralston Crawford were influential to his development as a professional photographer, and as an artist. He found a ready-made community of photographers at Chandler's Studio and Camera Store in Lafayette in the late 1930's. Oscar Chandler not only developed film and made prints for Morgan, but also provided valuable technical advice and guidance for Morgan in his formative years. Morgan found a similar supportive photographic community ten years later in Baton Rouge at the camera counter of Stroub's Drug Store and Southern Camera. Southern Camera was an important institution in Baton Rouge and many professional photographers benefited from the advice of owner John Lowry.

Morgan first met Fonville Winans in 1937 when he was a contract photographer for the state on a construction project that Morgan was supervising. Winans was already known as a photographer whose evocative images captured the distinctive life of the residents of Southwest Louisiana and was an important role model for Morgan as he began to explore his own vocation as a photographer. Though different in temperament and approach, these men remained friends and become two of the most important mid-20th century photographers in Louisiana.

Todd Webb first came to Louisiana on assignment for the Standard Oil Company and met Morgan while photographing in the region in late 1946 or early 1947. Webb is best known in Louisiana for his still photographs of the 1948 Robert Flaherty documentary film *Louisiana Story*. Flaherty's film chronicled the life of a twelve-year-old Cajun boy during the advent of the oil industry in Southwest Louisiana. Webb was a classic documentary photographer whose straightforward, empathetic approach to his subjects was in harmony with the personal documentary style that Elemore Morgan Sr. pursued in his own work. Morgan's friendship with Todd Webb was undoubtedly an important affirmation of the direction and significance of his own chosen approach to photography.

Morgan met Ralston Crawford while the Canadian artist was a visiting professor at the LSU Art Department in 1949. Crawford's penchant for abstract art and passion for his work influenced Elemore Morgan Sr. as well as Elemore Morgan Jr., who studied basic design with him at LSU for two semesters. Worldly, bohemian and politically radical, Crawford was an exotic personality in Baton Rouge in the 1940's. After living in Louisiana, two of Ralston Crawford's lifelong passions became New Orleans jazz and architecture, which were constant inspirations in his work. His abstract, precisionist approach to art was as foreign and exotic in Baton Rouge as his personae. A painter, printmaker and photographer, Crawford's insistence on the primacy of the essential geometries in his work harkens back to the purist approach of Cubism, and takes a similar approach to poetic abstraction grounded in the direct observation of his subject. This influence on Elemore Morgan Sr. may be seen in his increased interest in the industrial landscape and a greater concern for geometric relationships in his compositions. Crawford's

influence was more than formal. His example of an artist whose entire life was committed to his work was singular in a region with few working artists. Both Morgan and Crawford loved the people and culture of Louisiana. Despite their differences in personality and experience, this shared interest, along with an obsession with photography bonded these two men together. Elemore Morgan Sr. met both Webb and Crawford in the late 1940's, a critical time in his evolution as a photographer, and their respective influences both affirmed Morgan's previous direction and challenged him to continue to grow as an artist.

Publishing was critical to Morgan's development and recognition as a photographer. Morgan published six books and contributed regularly to professional journals and magazines for the petrochemical and timber industries. He became known for his insightful photographs of his home state in a series of books beginning in 1943 with *The Bayous of Louisiana* by Harnett Kane, followed by *All This is Louisiana* by Frances Parkinson Keyes in 1950, one year later in *5 Days in Baton Rouge* with Ed Kerr, *John Law Wasn't So Wrong* by Hodding Carter in 1952, and *The Lower Mississippi Valley* in 1962, again with Ed Kerr. His photographs continued to define many people's view of Louisiana posthumously with the publication of *The Face of Louisiana* by Charles East and *Louisiana, Its Land and People* by Fred Kniffen in 1968. Publishing was both a blessing and a curse for Elemore Morgan Sr. While publishing his photographs gave him steady assignments and an important source of income, it also limited the public understanding of his larger body of work as a photographer. As a working photographer, Morgan gained far more exposure from his publishing than he ever would from exhibitions and collections. This disparity is partly due to the nature of his career and his subject matter, but also because photography in the 1940's and 1950's did not have the visibility and status that it enjoys today. When photographing on assignment, it is clear that Morgan almost always took the opportunity to shoot a few frames for himself, sometimes in a mode decidedly different than the ones from the demands of the assignment. While many of his published photographs have become iconic images of a period of Louisiana history and culture, there is a private, more intimate view of that world waiting to be discovered.

One of the most telling examples of Morgan's independent personality was the book *The Sixties Ended It*, with text and photographs by Morgan. This book was a blunt critique of the deficiencies of contemporary architecture through the eyes of traditional building. Drawing on his own extensive experience of photographing traditional buildings and building modern ones, Morgan argued that the 1960's represented an important moment of transition away from the use of proportion based on the Golden Mean and an attention to details that gave buildings a deeper resonance with the human scale and experience. *The Sixties Ended It* was met with dismay and criticism from within the architectural community. Firstly, it was written by an independent, someone who was neither an architect nor an academic, and secondly, it was argued visually as well as verbally, a novelty at the time. That Morgan pursued a project that would inevitably be poorly received and criticized by its intended audience says much about his strong sense of conviction. In *An Elemore Morgan Kind of Day*, Morgan's friend and collaborator

Ed Kerr suggested that Morgan's success as a photographer rested on a unique combination of patience and decisiveness wed to a quick wit and well developed sense of humor. Morgan could bore into a subject, such as the countless photographs of one tree that he undertook late in his career, or he could work with a Zen-like simplicity, relying on only one careful shot to capture his subject. Ed Kerr relates one example of this simple approach when he and Morgan traveled to the fire at Belle Grove Plantation. Morgan had photographed the plantation many times and on this extraordinary occasion he drove miles to take only one shot.

> After arriving at the scene, Elemore erected his tripod, set his camera on exposure and relaxed. It took an hour, but when the moon appeared directly over the chimney he leisurely clicked the shutter and said "Let's go home." We had traveled twenty miles in the dead of night and one exposure is all he took.[1]

Elemore Morgan Sr.'s reputation is founded on his black and white photographs shot with a 4"x 5" Speed Graphic, Graphic view camera, or a Linh of Technica camera. These tools are by their very nature slow and cumbersome, but, when compared to the smaller 35mm negative, yield negatives of incomparable smoothness and detail. Morgan was so familiar with his chosen tools that he sometimes used the 4"x 5" camera for action shots like a smaller 35mm camera. His subjects, partially dictated by his commissions and partly personal choice, were predictable for the place and time. Vernacular architecture, plantation houses, folk life, the daily activities of the oil and timber industries, and the people of Louisiana were all standard subjects of the period. What is unusual about Morgan in comparison to his peers is his range of subjects, and the care and clarity he brought to them. Whether he was photographing the romantic ruins of a plantation house or the unique world of everyday Cajun life, his approach is that of a cultural insider. Unlike many photographers who preferred the romanticism of the past to present day reality, Morgan also gave the same attention and insight to contemporary life. He photographed the past and the present with an equal eye, embracing both the patina of history and the progressive era of the 20th century. Morgan's approach went far beyond the usual straightforward documentation of his subject, and often successfully captures the elusive mood of a place or the spirit of a time. This is the poetry that he brings to the everyday subject in his work.

Elemore Morgan Sr. worked in a period of historical and cultural transformation. Many of his photographs have taken on a new importance not only as historical documents, but as cultural artifacts that capture both the nation and the state of Louisiana at a critical historical juncture. From his first photographs in the late 30's until his untimely death from heart failure in 1966, Elemore Morgan Sr. was the prism through which many people saw life in Louisiana. He exposed thousands of negatives, many of which have never been exhibited or published. This exhibition demonstrates that we have only begun to examine the many facets of his distinguished body of work that will increasingly open a window and further define art and life in Louisiana in the mid-20th century.

[1] Ed Kerr, *An Elemore Morgan Kind of Day, Photographs by Elemore Morgan: Rural Life and Landmarks In Louisiana, 1937-1965*, exhibition catalog (Alexandria, Louisiana: Alexandria Museum of Art, 1965), p. 9.

THE ART OF ELEMORE MORGAN JR.

Elemore Morgan Jr. is known for his colorful paintings of vernacular architecture and the panoramic vistas of the prairies of Southwestern Louisiana. With the exception of the occasional Mississippi River scene and New Orleans cityscapes, the majority of Morgan's paintings concentrate on a thirty-square-mile-area between Kaplan, Abbeville and Maurice, Louisiana. Here, painting out-of-doors in the rice fields of summer and the crawfish ponds in winter, Morgan obsessively records the minute changes registered in a landscape defined by long low horizon lines, soaring clouds and the play of color across the earth and sky. He is also attracted to the region's vernacular architecture; the barns of the prairies and the corrugated industrial buildings in small towns like Abbeville and Kaplan. These buildings are the local version of the common American archetypal forms that have come to symbolize an increasingly vanishing way of life in the 21st century. Morgan also periodically revisits the traditional academic subjects of the female figure and still life, subjects that he increasingly intensifies with expressive color. However, the lifeblood of Morgan's paintings is his prairie landscapes painted on site, specific to a season and a time of day.

Elemore Morgan Jr. was born in Baton Rouge, Louisiana, on August 6, 1931, the only son of Elemore Morgan Sr. and Dorothy Morgan. Morgan remembers his childhood as an idyllic one spent roaming the fields and woods of the family farm in the semi-rural landscape just south of Baton Rouge. The family made regular visits to his maternal grandparents in Abbeville, just a few miles from where Morgan has chosen to spend most of his adult years. Morgan was often aware of his father's struggle to support his family while searching for his own direction as a photographer in a region with few opportunities and even fewer role models. His father's commitment to realizing the best in his work and his strong sense of personal integrity would remain an important source of inspiration for Morgan throughout his life. In 1935, Morgan and his mother moved in with an aunt in Lafayette while his father was recuperating from a debilitating lung problem in Kerrville, Texas. This experience, along with the family's economic setbacks during the Great Depression, and his father's unwavering persistence at establishing himself as a photographer, made Morgan aware that life was often difficult and unpredictable. These early experiences undoubtedly helped equip Morgan with resilience and a broad outlook on life that helped prepare him in his own struggle to become an artist. Even today, Morgan speaks of the impulse to make art as a compulsion, or, in his words, "an affliction," something that one must do in order to be whole.

The artistic impulse appeared early in Morgan's life and by high school he was painting and drawing regularly. His early work is typical of an adolescent living in a remote corner of the world left to choose his own subjects and find his own way in making images. Morgan's work from this period is dominated by dramatic action scenes such as boxers in the heat of the fight, imaginative combat scenes from the Second World War and heroic workers marching forward to a better future.

Dorothy Golden Morgan (left), Elemore Morgan Sr. (right)
Photo taken circa 1927

Photo of Elemore Morgan Jr., 1952
by Fonville Winans

Elemore Morgan Jr. enrolled in Louisiana State University (LSU) in 1948, and with the financial assistance of the Air Force ROTC program, graduated in 1952. Like many American universities in the mid-20th century, the art instruction at LSU was decidedly modernist, emphasizing understanding of basic design, abstract composition and the importance of intuition and artistic self-expression. The first of several influential teachers that shaped Morgan's early artistic outlook was the printmaker Caroline Durieux, who trained Morgan in the techniques of lithography, woodcut and etching. Equally important to this technical knowledge was her way of weaning Morgan from the melodrama of his high school art subjects. Durieux had the wisdom to let his adolescent subject matter, which was by now increasingly Freudian, run its own natural course and eventually vanish forever. Concentrating primarily on local landscapes and the abstract handling of the human figure, Morgan's first mature efforts at LSU art school exhibit an innate understanding of composition and a sure sense of line, both indicative of natural talent and a keen eye. His swamp scenes and figure compositions, while still formative works, have a tight, clear composition and crisp line, and look ahead to Morgan's permanent obsession with drawing as both an end in itself and a study medium.

During his sophomore year Morgan began studying basic design with the visiting artist Ralston Crawford. Crawford, himself a well-recognized modernist painter, printmaker and photographer, appreciated LSU for its proximity to New Orleans where he regularly traveled to seek out the Crescent City's jazz clubs and second line parades. Crawford's influence on Morgan was immediate as the young artist was challenged to push his understanding of composition and color into the unfamiliar realm of abstract design. Morgan credits Crawford with refining his understanding of the importance of composition through exercises that emphasized the overall geometric structure of a painting and the complex interaction of color and form. "When I first had Crawford in basic design, I didn't know what design really was, he taught me how to understand the importance of structure in a successful work of art."[1]

Ralston Crawford's influence on Morgan extended beyond the confines of the classroom. In addition to being Elemore Morgan Jr.'s professor at LSU, Ralston Crawford also became a friend of Elemore Morgan Sr., who was by now a well-established photographer in the region. Their common interest in photography and Louisiana culture cemented their friendship, and Crawford was frequently a guest at Morgan's home and dinner table. In a city with few models of a successful working artist, Crawford's exotic personae and his intense dedication to his work became a lasting influence on both father and son.

The third important influence of Morgan's college years was the young painter David Le Doux. Just a few years older than many of his students, Le Doux was born in the rice fields in Eunice, Louisiana, and was an undergraduate instructor while finishing his graduate studies at LSU. Although he had grown up in a world not that different from Morgan's own, Le Doux had served in the US Navy, traveled and had a much larger sense of the world. Most importantly for many of his students, he was a disciple

of the emergent style of American Abstract Expressionism. Where Crawford's modernism was grounded in prewar European Modernism and American Precisionism, Le Doux's approach to abstraction was a clear example of the American postwar approach that valued intuition, the importance of the subconscious mind, and the use of color as a vehicle for self-expression. From Le Doux, Morgan learned to move beyond his early dramatic realism and explore the role of intuition, archetypal imagery and spontaneity in creating an abstract painting.

Elemore Morgan Jr. was a member of the Air Force ROTC program at LSU and graduated during the Korean conflict in 1952. He was certain that he would be called to active duty, and after receiving his bachelor's degree, was commissioned in the United States Air Force. Six months later, he was sent to Korea. Unlike many who merely drifted with the currents of military service, Morgan purposefully used his years in the military as a time to expand his cultural understanding and further explore his commitment to becoming an artist. Morgan had joined the ROTC program as a way to help pay for college, and the Air Force in particular, he says, "because they had the shortest line." He spent most of his military career as a supply officer, a position which reinforced his natural penchant for order and detail. When possible, he traveled in Korea and Japan for rest and recreation, absorbing the character of the people, the details of the landscape as well as visiting the well-known monuments of Japanese art and architecture. While on leave in Japan, Morgan began to assemble a small collection of woodblock prints by the 19th century masters Hokusai and Hiroshige that insured the influence of Asian art would remain a presence and influence in his life and work.

Military life in a war zone was not the best setting for Morgan to further explore his compulsion to make art. The demands of military life insured that he could not draw or paint regularly, so Morgan turned to photography as a way to explore his new world. He bought the best rangefinder camera he could find at the base PX, a Contax II with a Zeiss lens, and began to photograph regularly. Although he occasionally could find the time for a quick drawing in a small sketchbook, photography was the medium he felt best suited his situation. Particularly important to his growing interest in photography as a vision tool was his discovery of Kodachrome transparency film. Morgan quickly realized that he could mail the exposed slide film away for processing and receive a box of vibrant color images back via post in less than two weeks. Longevity is one of the well-known characteristics of Kodachrome film, and Morgan's Kodachrome photographs of Korea and Japan are still strong vibrant images over fifty years after they were developed. The Air Force was an important formative experience for Elemore Morgan Jr., and against the odds, he found a way to further his understanding of the growing importance of art in his life and explore a radically different culture in the midst of turmoil.

Study for a Painting, circa 1944
Graphite on paper, 12" x 18"
Collection of Elemore Morgan Jr.

Self-Portrait (Oxford), 1955
Self-timed b&w photograph, 4" x 6"
Collection of Elemore Morgan Jr.

The ROTC program opened the doors of LSU for Morgan, and the GI Bill would do the same at Oxford University. In 1954 he left the United States to study at the Ruskin School of Art at Oxford University in England. As many Americans of his generation, he took advantage of the GI Bill to explore this extraordinary educational opportunity that would have otherwise been out of reach to him. Because of his undergraduate concentration in Modern art, Morgan felt he needed a solid grounding in traditional academic art to complete his education. Studying at the ancient school of Oxford University with fellow Americans Philip Morsberger, Ron Kitaj and John Updike, Morgan undertook the slow rigorous academic discipline of hand-to-eye coordination that had been the basis of European academic art since the 17th century. At the Ruskin School Morgan drew from the figure and painted with the muted palette of browns and grays lovingly referred to as the "Ruskin mud" by the students.

Morgan quickly felt the limitations of the academic curriculum and soon felt the need to explore image making beyond the well-confined boundaries of the academic training he had sought. Once again he turned to photography as a visual outlet, joined the Oxford Camera Club, and began to explore the city streets and the rural landscape with his Contax camera loaded with black and white film. He was able to use the darkroom at the camera club to develop and print his own negatives and was soon making his own images on a regular basis. Unlike his Korean experience with photography, Morgan had time to study the medium and realized photography's importance to his development as an artist. Photography rapidly became an important parallel investigation to his formal academic work in drawing and painting.

Another important influence during Morgan's Oxford years also came from an unexpected source. Morgan met the local painter Graham Sawyer at an exhibition of his work at the English Speaking Union in Oxford, and the two men soon became friends. Sawyer lived on the fringes of British society, made his way in life as a sometimes lecturer in the history of art, and worked independently as a painter. His approach to painting was far more contemporary than the teachers at the university and Morgan responded to the freshness of his direct observation captured in a lively palette. Sawyer had lived in the Hampstead countryside where the English landscape painter John Constable had painted, and he shared Constable's concern for the effects of light and atmospheric conditions in his work. In many respects Sawyer was as influential, if not more so, on Morgan's artistic development than the young artist's teachers at the Ruskin School. Ralston Crawford had taught Morgan the importance of structure and organization in a painting during his undergraduate years at LSU. Sawyer's work impressed upon Morgan the role of luminance and the handling of light in a painting. Sawyer also introduced Morgan to the delicate technique of Chinese ink and brush painting, an approach also worlds apart from the academics at the Ruskin School. Just as influential as Sawyer's vision and techniques was his independence from the official British art scene. His unconventional approach to surviving as a working artist would add to Morgan's earlier examples of his father and Ralston Crawford and remain important during Morgan's lean years of finding his way as an artist after returning to Louisiana.

One of the most important resources that Morgan discovered at Oxford was the collection of masterworks at the Ashmolean Museum. There, students could handle and study Old Master drawings and paintings, gaining firsthand knowledge of these historical paintings and the works of the Impressionists and Post-Impressionists. Morgan closely studied the works by Corot, Chardin and the watercolors of Turner. The Ruskin School was located in a wing of the Ashmolean Museum and Morgan found a sharp contrast between the works in the museum collection and the paintings at the school. Morgan remembers, "I saw fire in the work there in the galleries that the work in the studios didn't have." Morgan began to paint independently, increasingly working in his apartment away from the school. One reason for this change was Morgan's steady rejection of the dark, murky academic palette and his assimilation of the brighter colors of the Post-Impressionist works he had studied in the Ashmolean Museum. Morgan's growing interest in Post-Impressionism was also accelerated by his obsessive reading of biographies of the Post-Impressionist painters from the Oxford Library. "The Ashmolean also had a great library," he recalls, "and I read every biography of the Post-Impressionist painters I could get my hands on. I not only wanted to learn about their work, but also about their lives, how they lived, how they developed as artists. I wanted to understand what made them tick." Morgan also read biographies of Rembrandt, Goya, Vermeer and Blake. His artistic universe was expanding and he was discovering the foundations of his own artistic voice.

The academic schedule at Oxford was three terms of eight weeks, then six months off. Morgan took advantage of this schedule to travel throughout Europe and the Middle East on frugal exploratory trips centered around photography and painting. In 1956, Morgan traveled by train to Naples, Italy, then by ship to Greece and the Middle East. He returned to Naples and worked his way north by train and hitch-hiking for four months. In France, he followed the old French Romanesque pilgrimage routes. "My purpose was to trace the pathways of Western Civilization as I understood it." Morgan discovered that he enjoyed working gesturally while at the Ruskin School, and began working with gouache on paper to capture the immediacy of his vision. This technique was particularly useful during his travels, and the small gouache paintings made in Southern Europe and the Middle East are among the most distinguished of his years abroad and would point the way to his mature work in acrylic on Masonite years later.

Morgan graduated from The Ruskin School of Art at Oxford University with a Certificate in Fine Arts in 1957. His experience there, while often challenging for a young man from the rural South, grounded him firmly in the fundamentals of traditional painting and drawing, brought him into contact with the major movements of European art and architecture and furthered his sense of self-discovery as an artist. After a few weeks of post-graduate travel, and with his student years behind him, it was time to come home. Elemore Morgan Jr. was the first American to earn a Certificate in Fine Arts from the Ruskin School. After three years of support from the GI Bill in Europe, Morgan found himself back in Louisiana struggling to find a way to

Angouleme, France, Street Scene, circa 1956
B&W photograph, 4" x 6"
Collection of Elemore Morgan Jr.

Torso, 1956
Graphite on paper, 22" x 15"
Collection of Elemore Morgan Jr.

support himself as an artist. He had always known he would return to Louisiana and paint in the flat rice fields on the prairies of Louisiana. In the 1980's he confided to fellow painter Calvin Harlan that "while in England in the 1950's, studying drawing, mainly, at the Ruskin School at Oxford I 'dreamed' of this landscape, while longing for its colors in strong sunlight." With few exhibition opportunities, and even fewer possibilities for sales, Morgan lived modestly in an apartment house in Lafayette. He had participated in the juried show *Young Contemporaries* in London in 1955 and mounted a one-person exhibition in Lafayette upon his return to the region in 1957. However, Morgan did not begin exhibiting his work regularly until the early 1970's. The 1950's and the early 1960's were lean years for Morgan and he explored the possibility of making a career of architectural commissions in paint and mosaic. Inspired by the encouragement of his friend and college roommate, the Lafayette architect Neil Nehrbass, he executed the mosaic for an archway at the Chancery Building of the Archdiocese of Lafayette in 1964. With architectural jobs difficult to find and little other outlet for his work, Morgan was eventually forced to take a part-time job making signs at the local Sears and Roebuck. In spite of the much-needed comfort of a regular paycheck, Morgan soon became frustrated with the corporate concern for the quantitative, but held on to the security of this position for some time.

In spite of the hardships of this period of his life, it was also a time of gestation, study and reflection. Morgan's schedule allowed him some time to draw and read. He read voraciously and digested the ideas and experience from his time in Europe. Morgan painted landscapes on-site regularly while in England, and in 1962-1963, executed his first *plein-air* Louisiana landscapes. When he began painting the canals and fields outside of Lafayette, Louisiana, Morgan adapted the quick, gestural approach he had developed in Europe to his large panels painted on-site. One important development in Morgan's early landscape paintings was his discovery of newly available acrylic paints. Acrylic paints dry fast, an important attribute for Morgan's desire to execute large works while painting out-of-doors. He quickly realized that these new polymer-based paints were very similar in feel to the gouache that he had become accustomed to using in Europe. This new medium, paired with the use of Masonite panels, provided the combination that he would use for the next forty years.

His early prairie paintings were circular or rectangular with gently rounded edges and concentrated on the complex communal canal systems that carried water to the fields. Rendered in muted colors on a highly textured ground, these works are composed with tight geometric compositions and a delicate balance between line, texture and structure. By the 1980's, the shapes became increasingly complex, often with multiple panels and his palette became brighter and more expressive. Sometimes he would cut the panel to match the scene and with others, he would compose on a precut shape. In a line that runs from *Control Structure-Clouds 1968* through the freely painted, semi-abstract work *Cut Crossing 1978,* to *North of Raine 2001,* Morgan's landscapes became increasingly experiential. Working directly into the sun to capture the full play of color in the scene, Morgan's intensified palette recreates the experience of the landscape rather than a simple topographical description of the scene.

A new opportunity opened up an unexpected path in Morgan's life in 1965. Although he had never thought of a teaching career, he was invited to teach as a one-year sabbatical replacement at the University of Southwest Louisiana. He retired from the faculty there thirty-two years later. Morgan was a natural teacher, bringing the same intensity and commitment to the classroom that he does to his painting. The teaching job at the university brought about a new period of stability for the young artist, and allowed him to focus increasingly on his own work. Morgan's expressive landscapes and river scenes from the mid-1960's to the early 1970's stand in sharp contrast to the dominant trend in American art of the period. Minimalism, the New Realism and Conceptual Art were ascendant in an era that seriously discussed "the death of painting" in favor of experimental sculpture and new media. Morgan finished his studies in the mid-1950's, an era dominated by Abstract Expressionism. The New York School emphasized scale, flatness and the expression of subconscious impulses and dominated the magazines, the universities, and increasingly, the museum. Although Morgan was impressed with the gestural approach of Franz Kline and Willlem de Kooning, the larger ideas of Abstract Expressionism were never a major influence on Morgan's work. A more lasting influence was the European inflected Modernism of his teacher Ralston Crawford, whose abstract compositions were nearly always grounded in perception rather than non-objectivity. While Morgan's early years follow the same trajectory of many of his peers, the substance of his experience does not. Morgan's investigation of Asian culture during his military service buffered him from the insular climate fostered by many artists and critics that saw in Abstract Expressionism an aesthetic equivalent of Manifest Destiny in the ascendancy of American Art after the Second World War. Instead of following the playbook of the New York School, he set out on his own path to find a singular aesthetic vision. Morgan's graduate training in the European academic tradition propelled him even further from the prevailing trends. While in England, he absorbed the lessons of Constable, Turner and the Post-Impressionists, as well as contemporary English painters such as Paul Nash and Stanley Spencer. Morgan returned to Louisiana and began to paint perceptual based landscapes drawn from his immediate world, an approach that was considered decidedly rear-guard in an avant-guard dominated art world. Morgan was consciously traversing a highly individual path that opposed the dominant thinking of the period by choice. In his words:

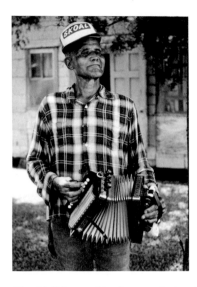

(Creole) Cajun musician Freeman Fontenot standing in front of his home near Basile, LA, 1981. Photo by Elemore Morgan Jr.

> I think that art is ungovernable. It comes unbidden. We can try to be well organized, hard-working, determined and pure of heart – and all that is good and necessary, but the art comes when it is ready, and it helps if you are ready. Because it remains something of a wild beast, ruthlessly seeking the [truth], it can't be managed or well behaved. This is why it doesn't institutionalize well. Art schools, museums, the galleries, the entire art apparatus does its best to impose some order and civility, but the beast will out in its own good time. Am I being romantic? Yes, I expect so. So what? Those terms barely dent the hide of art.[2]

Elemore Morgan Jr. teaching in a drawing class, University of Louisiana at Lafayette, 1997. Photo by K.P. Bienvenu

The path Morgan chose for himself is both linear and cyclical. His work unfolds in a steady exploration of the same subjects over time. He returns repeatedly to the same places and same themes over a period of many years. His themes, landscape, the figure, still life compositions and the occasional history painting, are the traditional themes of Western art. Morgan's landscapes are subtly inflected with a wide range of influences that reflect his experience of the world. In assimilating diverse influences over time, Morgan has sought to understand the vision of other artists, yet these influences are absorbed and transformed into a style that is distinctively his own.

The cyclical nature of Morgan's path may be seen in his recent directions. In 2003 he began a painting, *Conversations with Joe Q___, 2nd Lt. USAF, KIA 1953,* 2005 based on the death of a fellow soldier in the Korean War. In 1994 he returned to Japan to paint and revisit monuments and landscapes he had not seen in forty years. In 1995 he returned to England and painted on the same sites of his student years. For the last several years he has begun work on a monumental series of paintings, *America,* based on sketches and photographs that he has assembled over the last half a century. Morgan's steady evolution as an artist has weathered the passing trends and major movements in the art world. Working outside of the defining paradigms of our time, his work has followed a steady, inner directed course for the last four decades and has become an important cornerstone of art in Louisiana.

David Houston
Chief Curator
The Ogden Museum of Southern Art
University of New Orleans

[1] All artist's quotes are from studio interviews conducted October 2004 through July 2005.

[2] Elemore Morgan Jr. unpublished artist's statement.

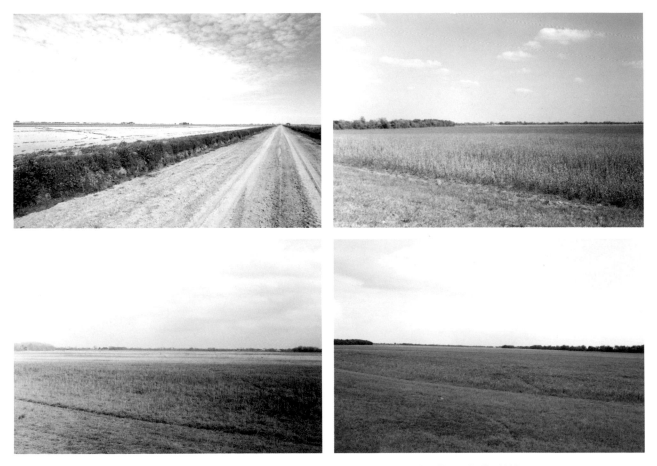

Road and Rice Field, (top left), Fields in three seasons from the porch of Elemore Morgan Jr.'s studio. Photos by David Houston

Elemore Morgan Sr.

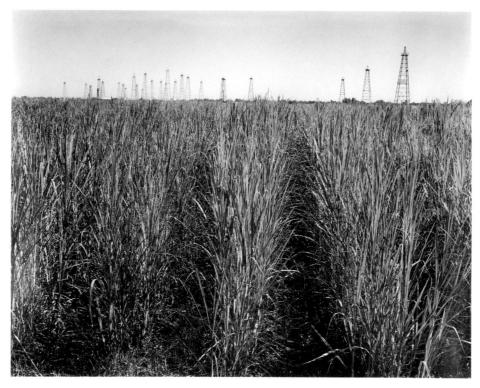

Oil Derrick and Growing Sugar Cane, J.P. Duhe Plantation, New Iberia, 1949
Silver gelatin print, 19.5" x 15.75"
Collection of The Ogden Museum of Southern Art, UNO

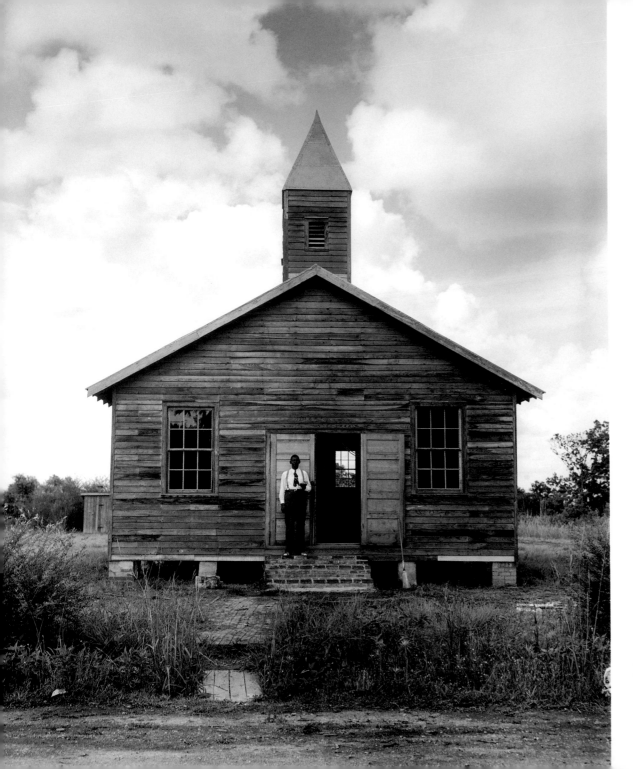

Little Zorah Church, New Iberia, LA, Rev. Parker in door, 1943
Silver gelatin print, 15.75" x 19.5"
Collection of The Ogden Museum of Southern Art, UNO

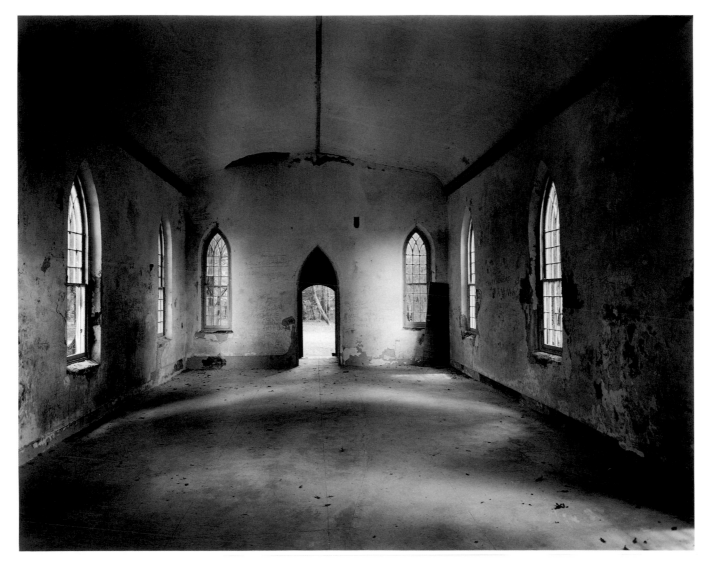

St. Mary's, Wyenoke, LA, 1958
Silver gelatin print, 19.5" x 15.75"
Collection of The Ogden Museum of Southern Art, UNO

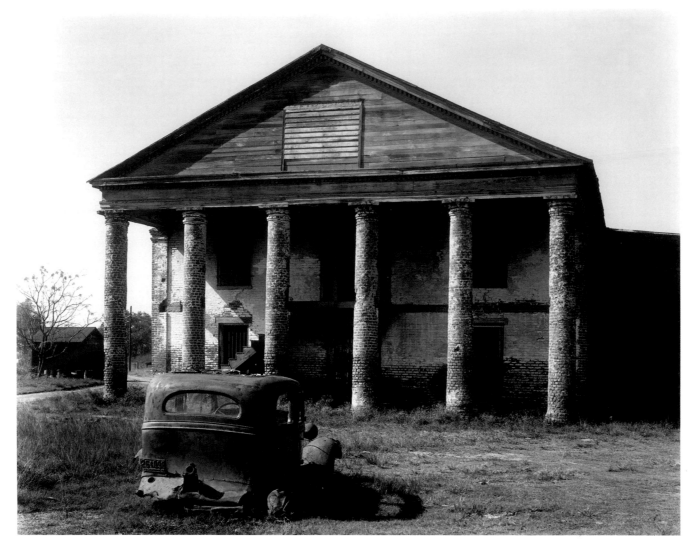

Remains of Hill Plantation Sugar House across from Baton Rouge, LA,
1951, silver gelatin print, 19. 5" x 15.75"
Collection of The Ogden Museum of Southern Art, UNO

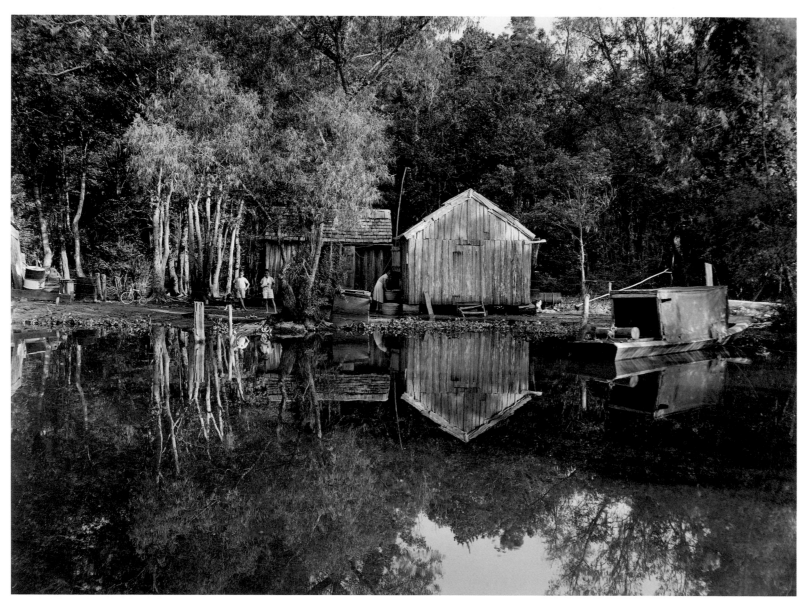

Brusly St. Martin, 1949
Silver gelatin print, 19.5" x 15.75"
Collection of The Ogden Museum of Southern Art, UNO

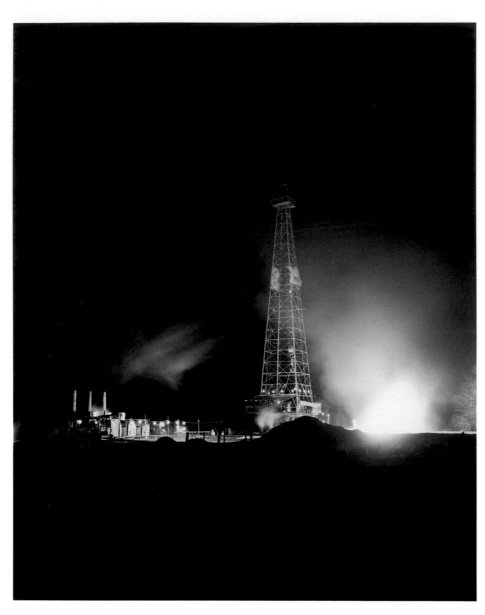

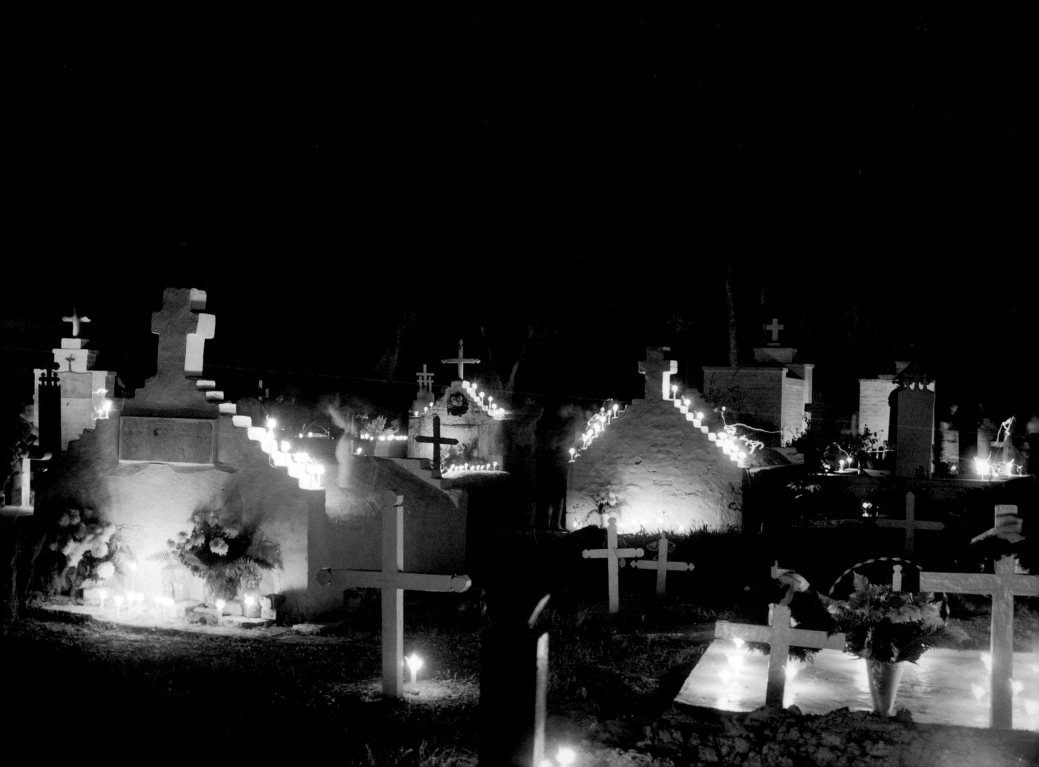

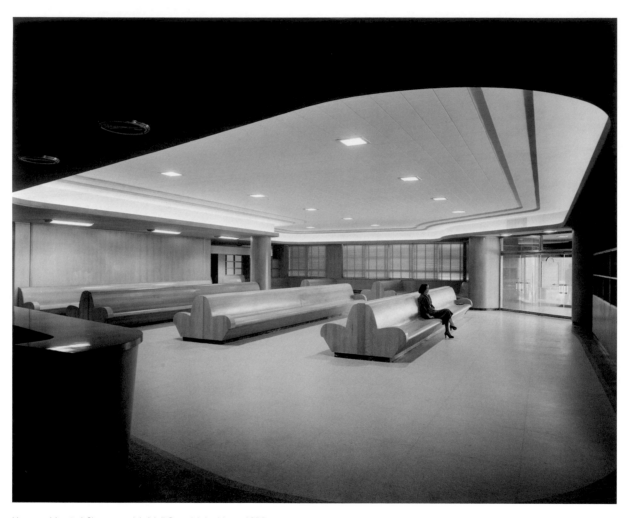

Veterans Hospital, Shreveport, LA, Neil Somdal, Architect, 1950
Silver gelatin print, 19.5" x 15.75"
Collection of The Ogden Museum of Southern Art, UNO

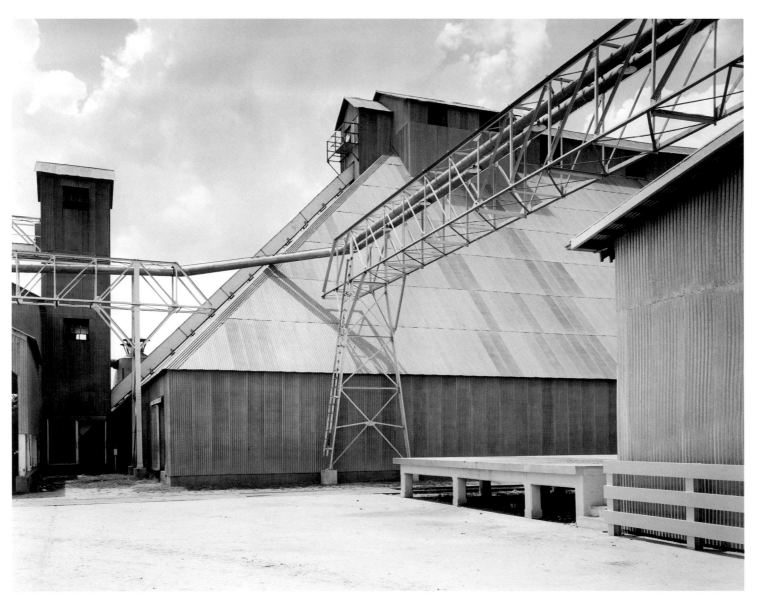

Olin Mill, Huttig Ark., 1957
Silver gelatin print, 19.5" x 15.75"
Collection of The Ogden Museum of Southern Art, UNO

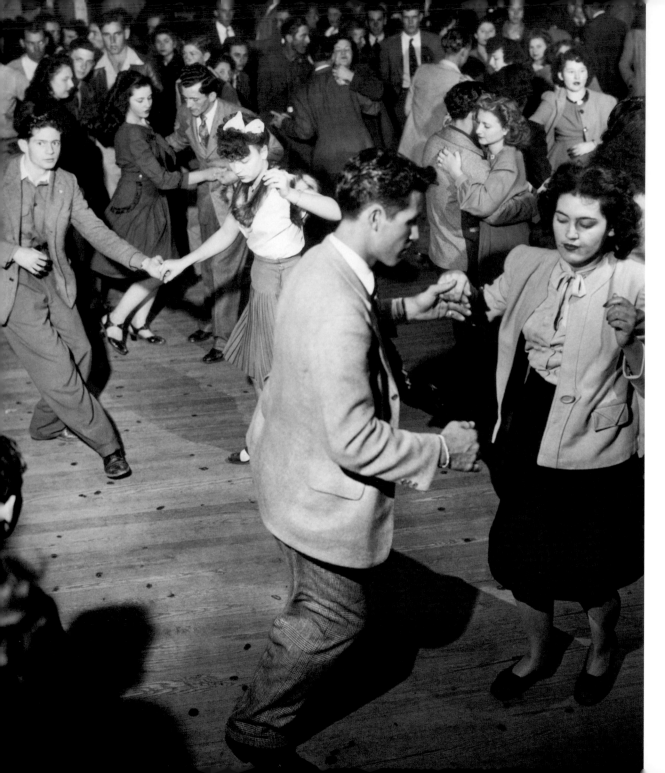

Dancers at Fais Do-Do, 1948
Silver gelatin print, 9.25" × 7"
Collection of Elemore Morgan Jr.

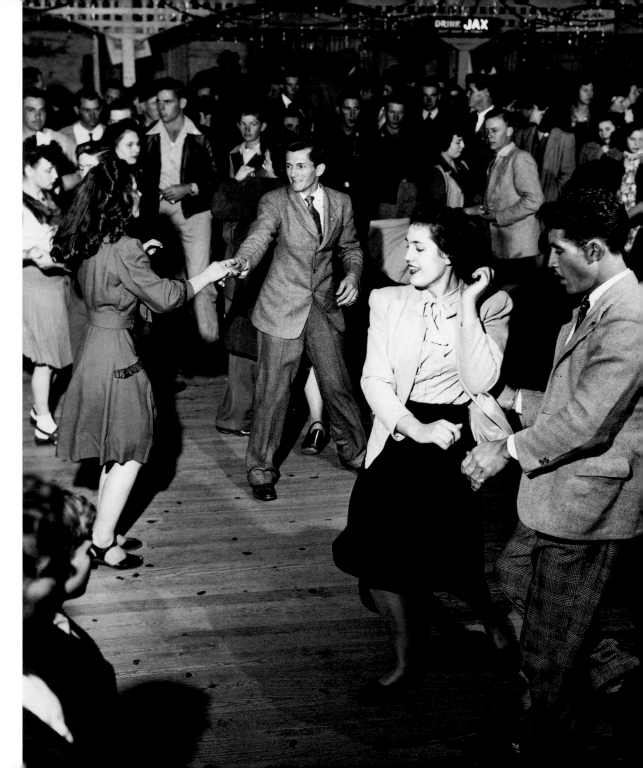

Dancers at Fais Do-Do, 1948
Silver gelatin print, 9.25" x 7"
Collection of Elemore Morgan Jr.

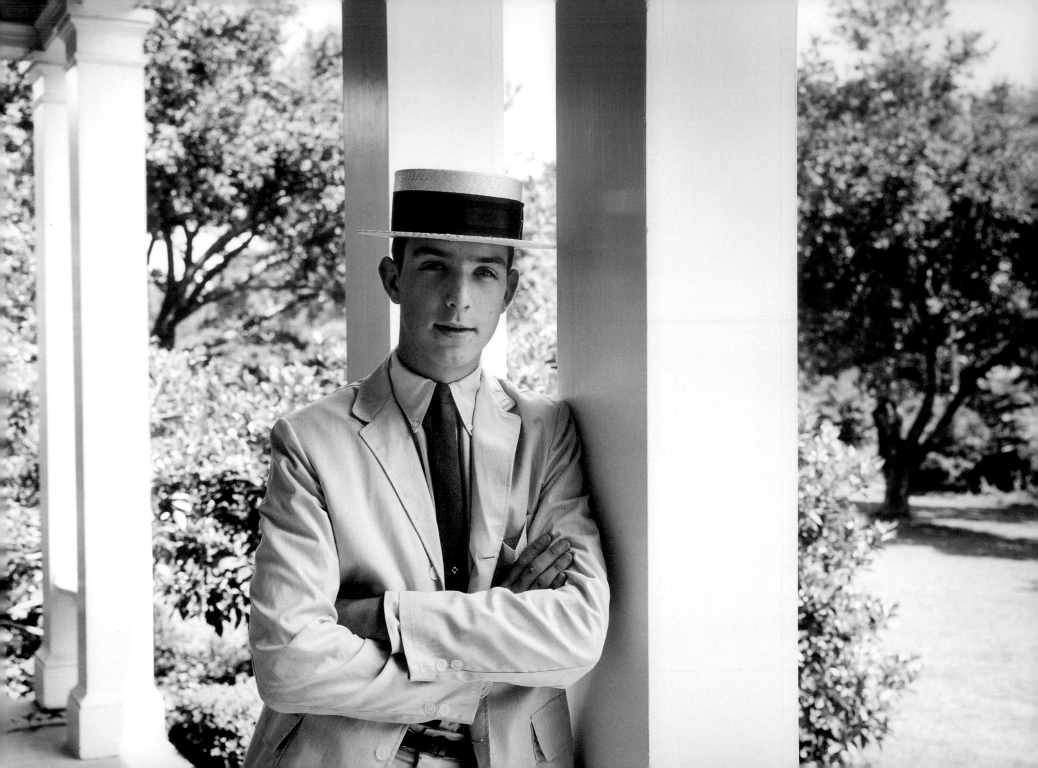

Industrial Lumber Company, Inc, Elizabeth, LA, 1958
Silver gelatin print, 19.5" x 15.75"
Collection of The Ogden Museum of Southern Art, UNO

Frank Grace at a Family Wedding, Abbeville, LA, 1959 (left)
Silver gelatin print, 19.5" x 15.75"
Collection of The Ogden Museum of Southern Art, UNO

Elemore Morgan Jr.

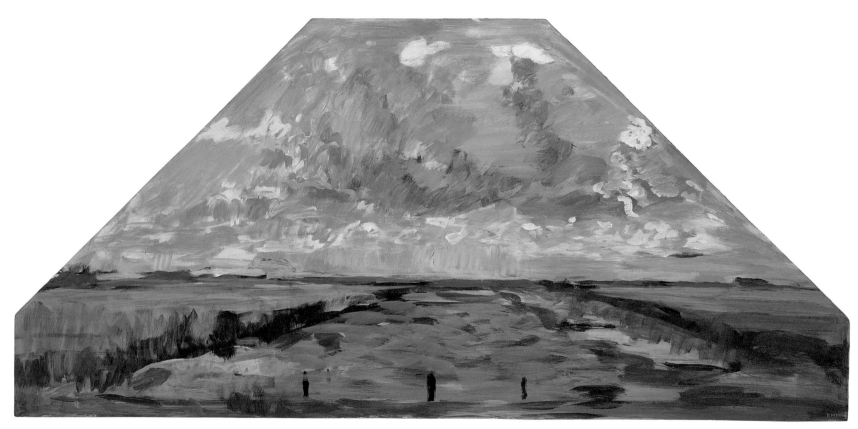

Canal Geometry, 1984
Acrylic on Masonite, 26" x 52"
Collection of Mr. and Mrs. James Edmunds

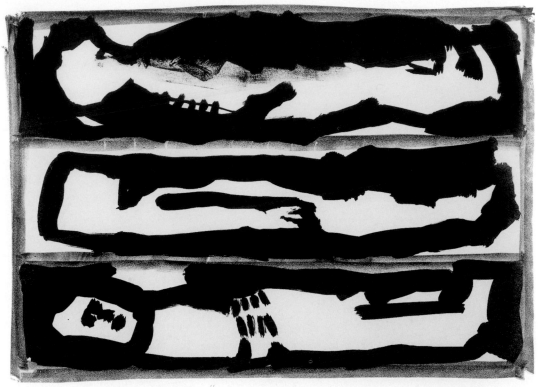

"When Johnny Comes Marching Home Again"

When Johnny Comes Marching Home Again, 1952
Lithograph, 12" x 17"
Collection of Elemore Morgan Jr.

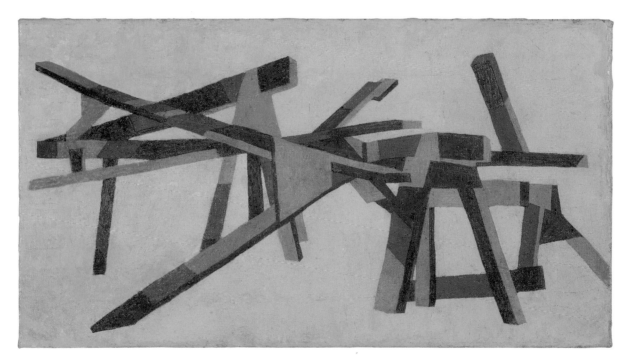

Traffic Barriers, 1950
Oil on canvas, 10" x 18"
Collection of Elemore Morgan Jr.

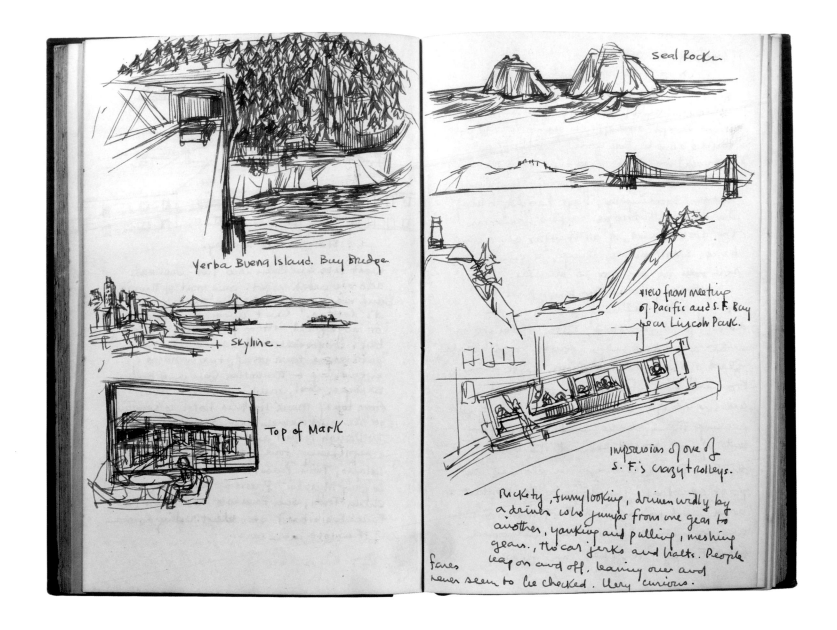

Seal Rocks

Yerba Buena Island. Bay Bridge.

Skyline.

Top of Mark

view from meeting
of Pacific and S. F. Bay
near Lincoln Park.

impressions of one of
S. F.'s crazy trolleys.

Rickety, funny looking, driven wildly by
a driver who jumps from one gear to
another, yanking and pulling, meshing
gears, the car jerks and halts. People
leap on and off. Leaning over and
fares never seem to be checked. Very curious.

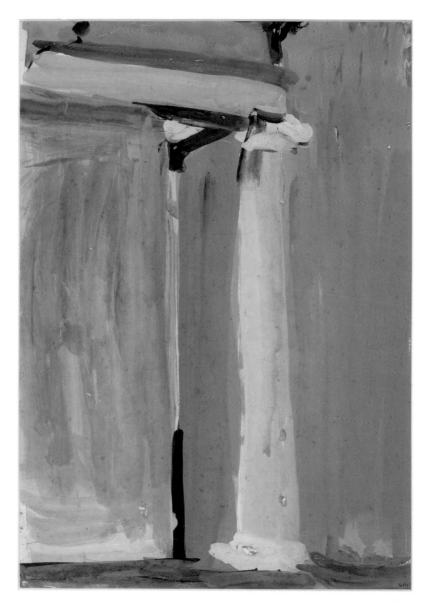

Pages from a sketchbook (left)
Views of San Francisco, 1953
Collection of Elemore Morgan Jr.

Erectheum, 1956
Gouache on paper, 8.5" x 13"
Collection of Elemore Morgan Jr.

Cezanne's Mountain, 1956
Gouache on paper, 10" x 13.75"
Collection of Elemore Morgan Jr.

Golan Heights, 1956 (right)
Gouache on paper, 9.63" x 13.25"
Collection of Elemore Morgan Jr.

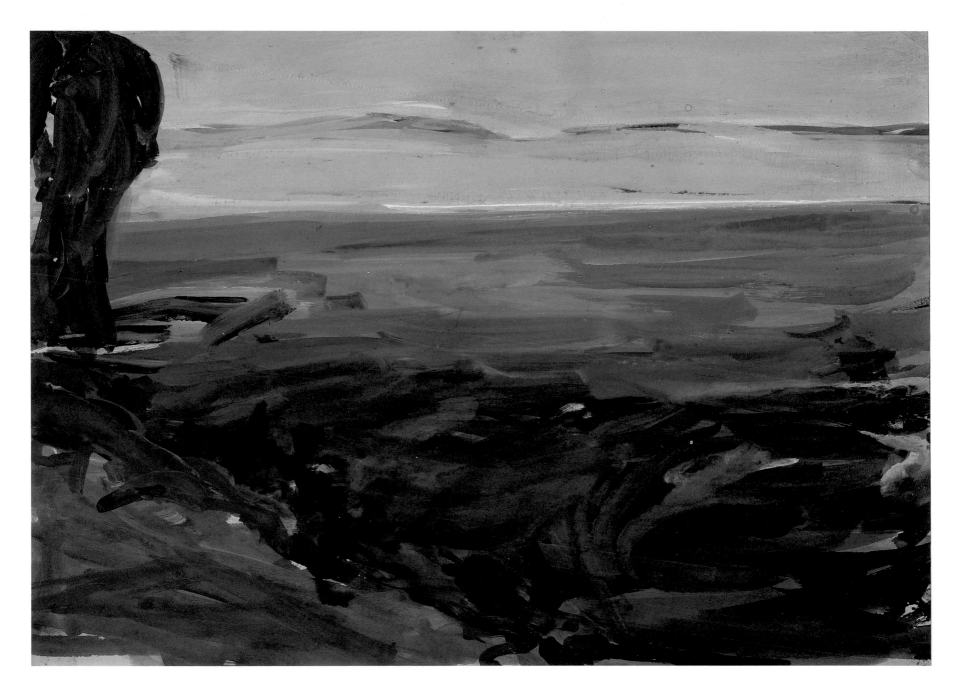

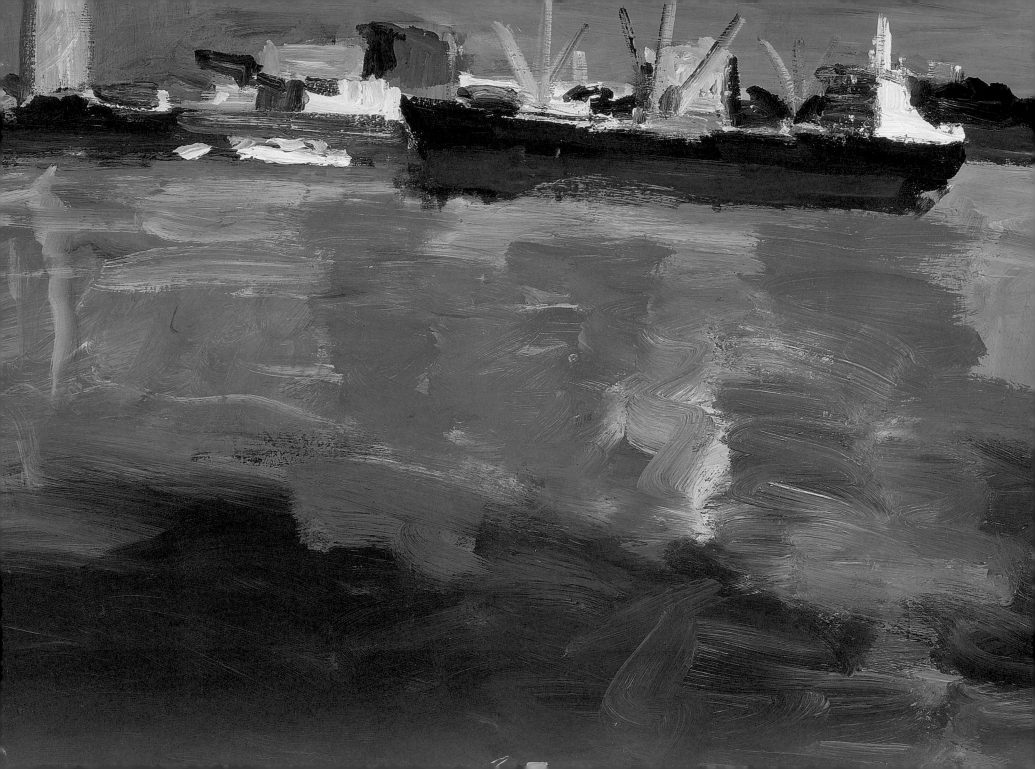

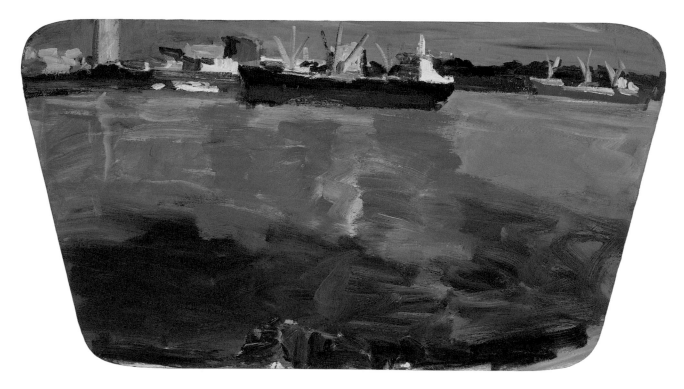

View of Baton Rouge, 1970 (detail left)
Acrylic on Masonite, 22" x 48"
Collection of Allen Bacqué

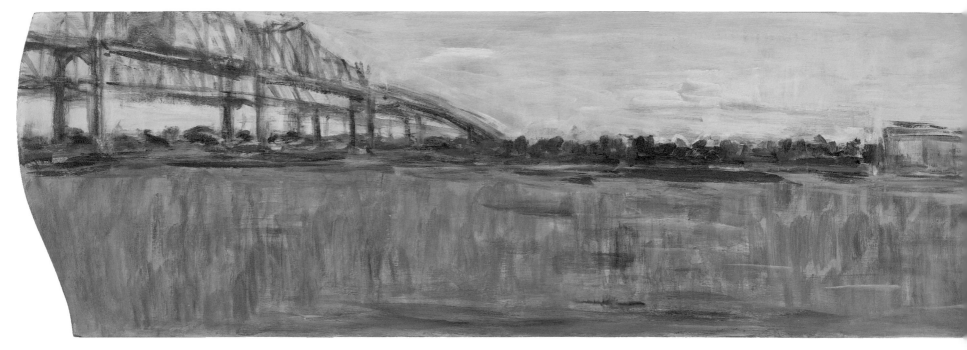

Rivers Edge, 2005
Acrylic on Masonite, 16" x 95"
Collection of Rhett Majoria

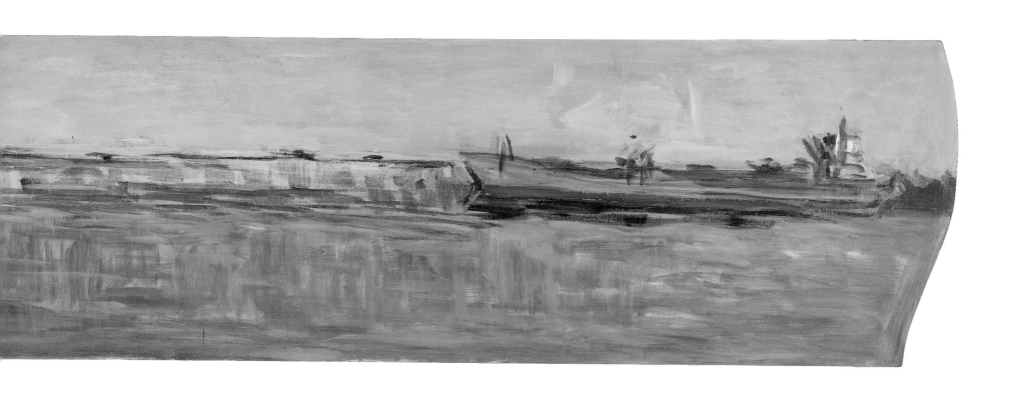

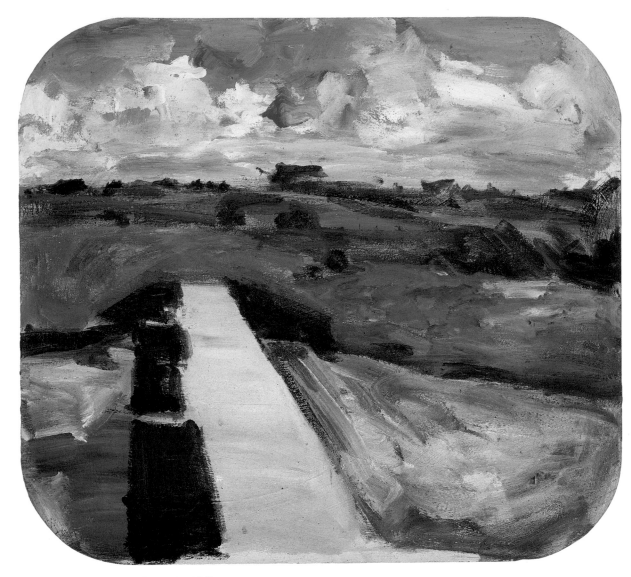

Control Structure-Clouds, circa 1969
Acrylic on Masonite, 18" x 18"
Collection of Janet and Neil Nehrbass

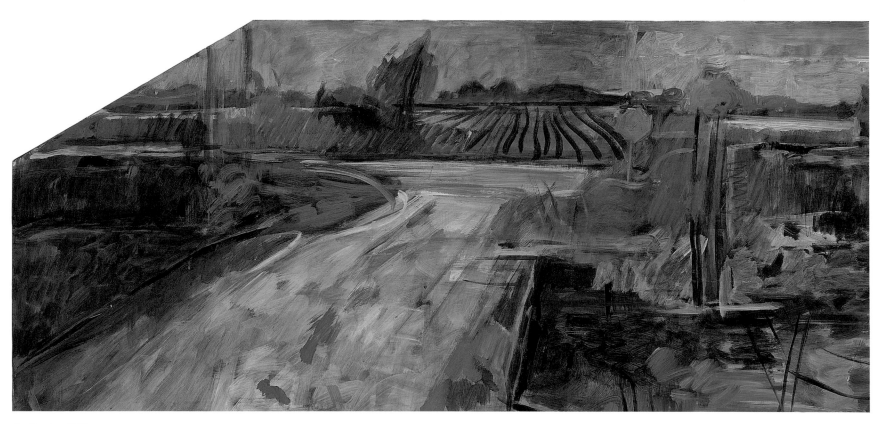

Cut Crossing, 1978
Acrylic on Masonite, 32.5" x 66"
Collection of Elemore Morgan Jr.

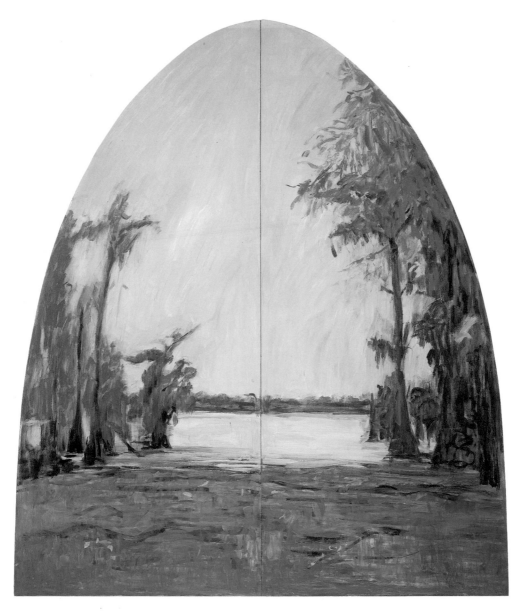

Lake Martin view, 2000 (detail right)
Acrylic on Masonite, 64" x 56"
Collection of Richard Chachere

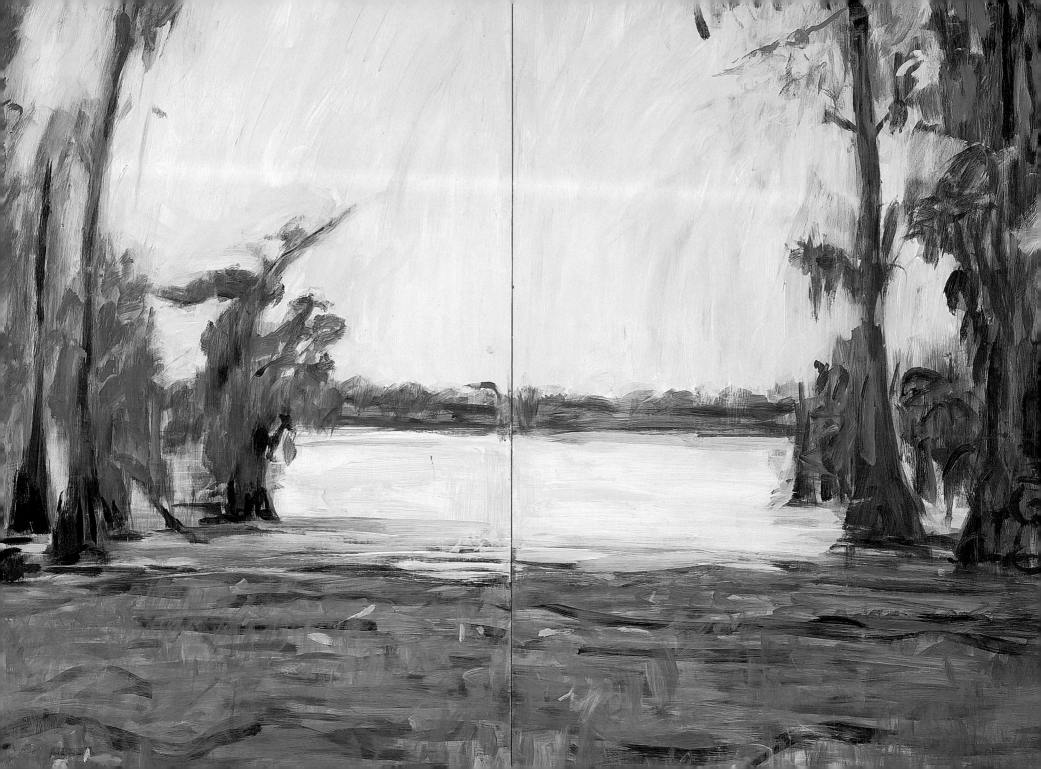

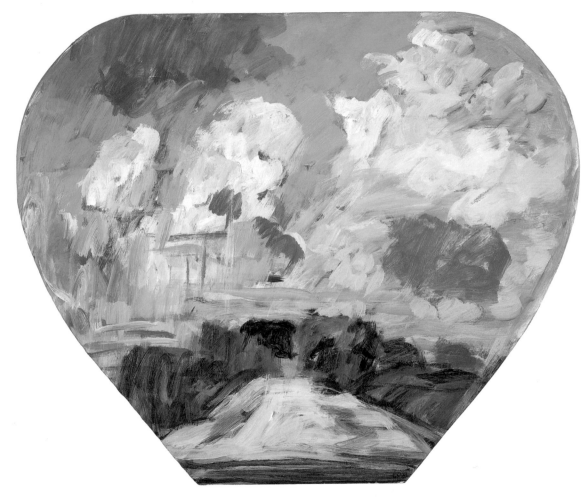

Summer Road, 1980
Acrylic on Masonite, 22.25" x 26.5"
Collection of the Lafayette Natural History Museum

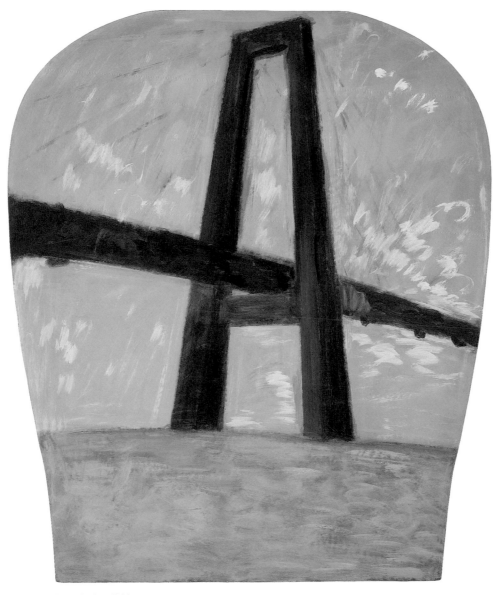

Luling Bridge, 1988
Acrylic on Masonite, 56" x 47"
Collection of Elemore Morgan Jr.

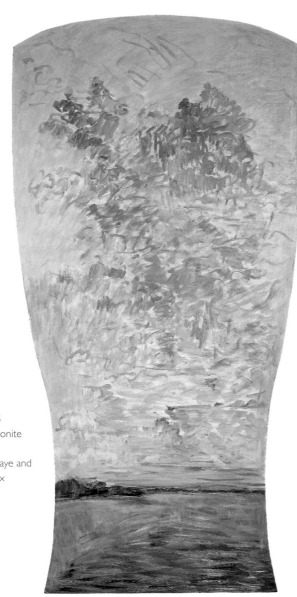

In the Sky, 2005
Acrylic on Masonite
95" x 47.5"
Collection of Faye and
Eddie Cazayoux

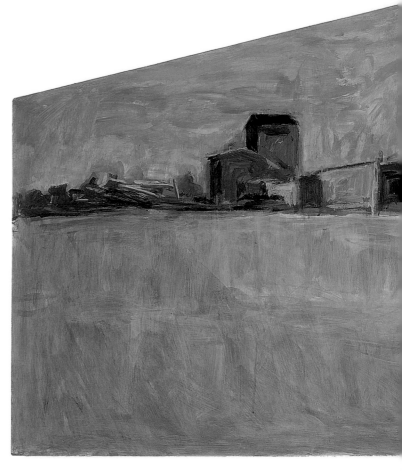

Industrial Facade, 1995
Acrylic on Masonite, 38.5" x 95"
Collection of Elemore Morgan Jr.

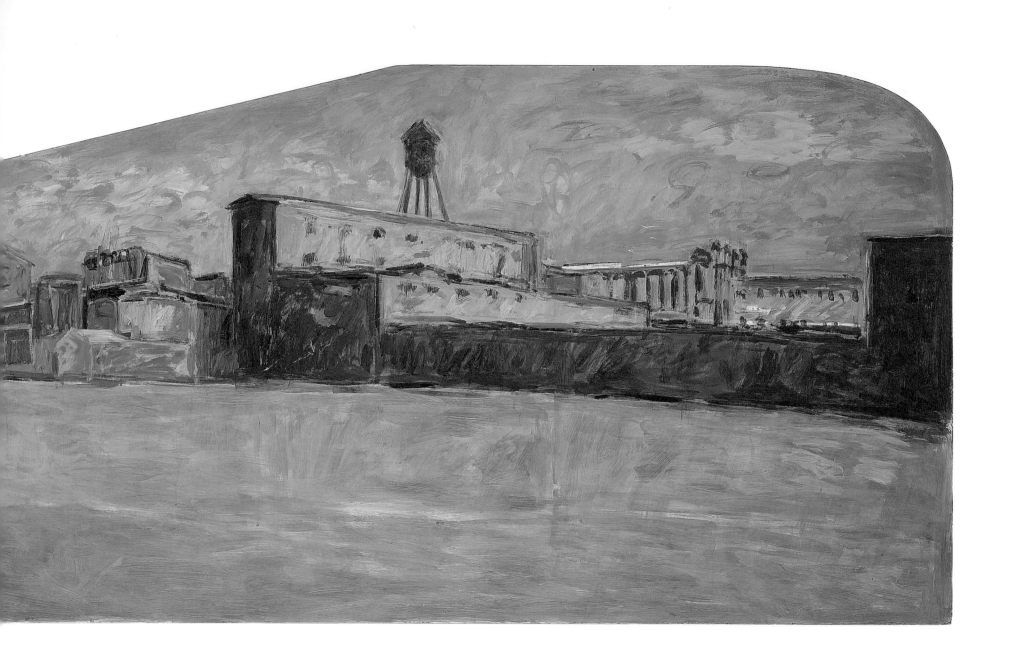

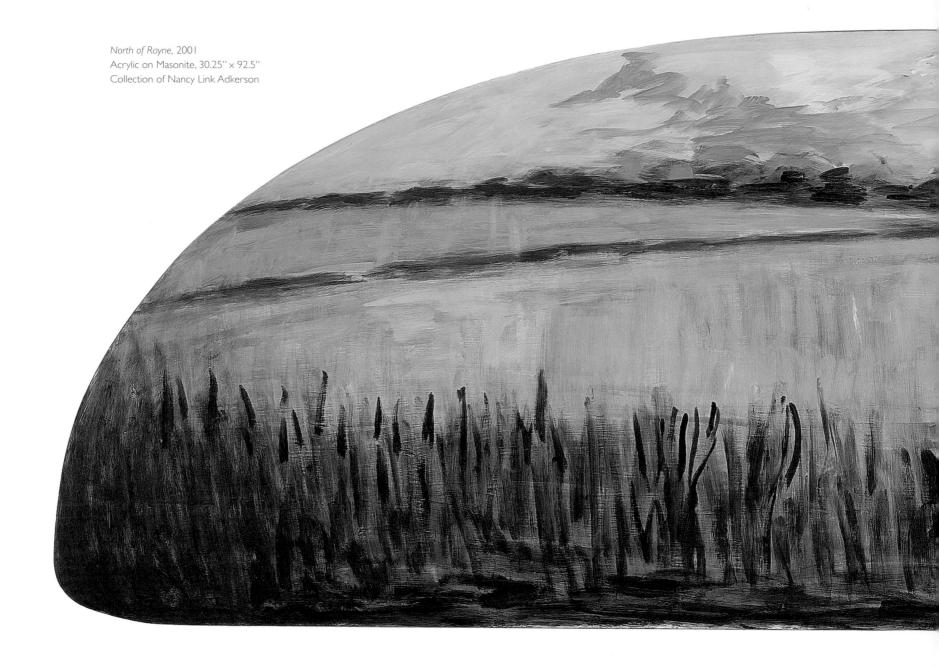

North of Rayne, 2001
Acrylic on Masonite, 30.25" x 92.5"
Collection of Nancy Link Adkerson

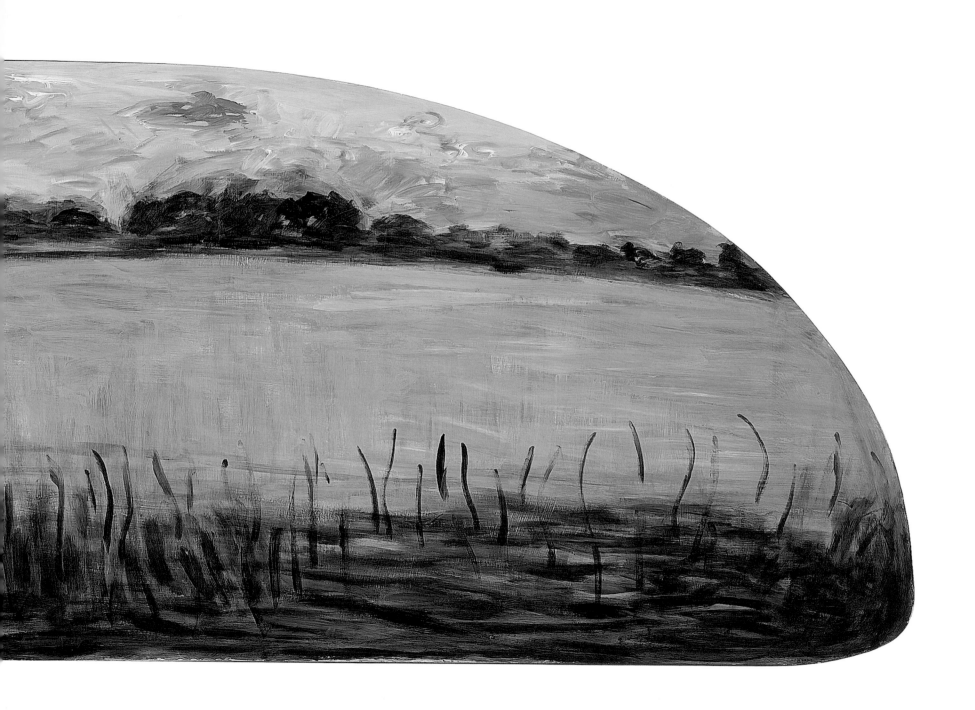

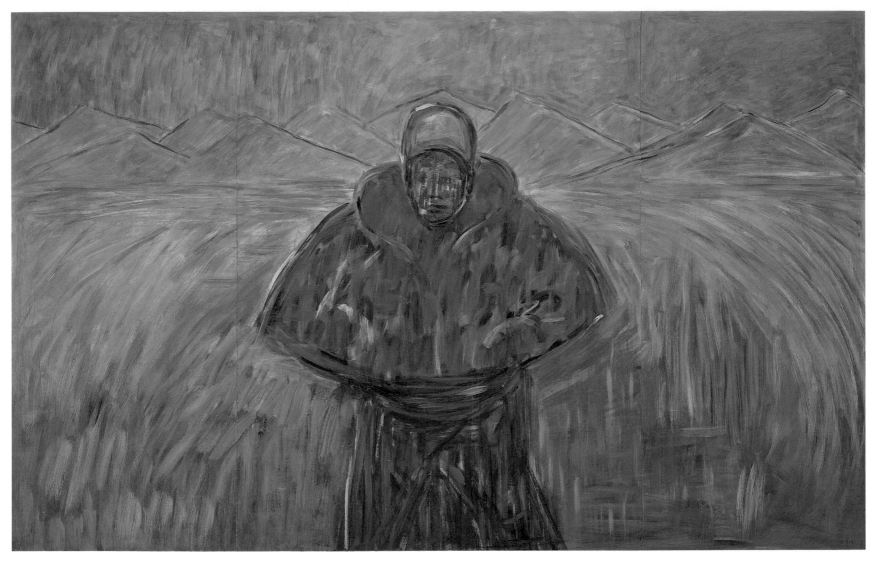

Conversation with Joe Q_____, 2nd LT. USAF, KIA, 1953, 2005
Acrylic on Masonite, 60" x 95"
Collection of Elemore Morgan Jr.

USA Global View, 1993 (right)
Pastel and charcoal on paper, 12" x 18"
Collection of Elemore Morgan Jr.

CHECKLIST OF EXHIBITION

ELEMORE MORGAN SR.

1. *Remains of Hill Plantation Sugar House across from Baton Rouge, LA,* 1951, Silver gelatin print, 19.5" x 15.75", Collection of The Ogden Museum of Southern Art, UNO
2. *Magnolia Ridge, Washington, LA,* 1962, silver gelatin print, 19.5" x 15.75", Collection of The Ogden Museum of Southern Art, UNO
3. *Boat of Louis Gottlieb on Lake Ponchartrain,* 1949, silver gelatin print, 19.5" x 15.75", Collection of The Ogden Museum of Southern Art, UNO
4. *Weeks Island Salt Mine,* 1964, silver gelatin print, 19.5" x 15.75", Collection of The Ogden Museum of Southern Art, UNO
5. *Lides Plantation, Newellton, LA,* 1949, silver gelatin print, 19.5" x 15.75", Collection of The Ogden Museum of Southern Art, UNO
6. *Uncle Sam Plantation,* 1937-38, silver gelatin print, 19.5" x 15.75", Collection of The Ogden Museum of Southern Art, UNO
7. *Industrial Lumber Company Inc., Elizabeth, LA,* 1958, silver gelatin print, 19.5" x 15.75", Collection of The Ogden Museum of Southern Art, UNO
8. *Washington Parish Fair, Boy Handling Swine in Judging Ring,* 1955, silver gelatin print, 19.5" x 15.75", Collection of The Ogden Museum of Southern Art, UNO
9. *Graveyard, All Saints Day,* 1945, silver gelatin print, 19.5" x 15.75", Collection of The Ogden Museum of Southern Art, UNO
10. *Brusly St. Martin,* 1949, silver gelatin print, 19.5" x 15.75", Collection of The Ogden Museum of Southern Art, UNO
11. *Louisiana State Police,* 1931, silver gelatin print, 19.5" x 15.75", Collection of The Ogden Museum of Southern Art, UNO
12. *Oil Derrick and Growing Sugar Cane, J.P. Duhe Plantation, New Iberia,* 1949, silver gelatin print, 19.5" x 15.75", Collection of The Ogden Museum of Southern Art, UNO
13. *Belle Grove, After Fire,* 1952, silver gelatin print, 19.5" x 15.75", Collection of The Ogden Museum of Southern Art, UNO
14. *Oak Tree,* silver gelatin print, 19.5" x 15.75", Collection of The Ogden Museum of Southern Art, UNO
15. *Rosedown, West Fel. Parish,* 1950, silver gelatin print, 19.5" x 15.75", Collection of The Ogden Museum of Southern Art, UNO
16. *Veterans Hospital, Shreveport, LA, Neil Somdal, Architect,* 1950, silver gelatin print, 19.5" x 15.75", Collection of The Ogden Museum of Southern Art, UNO
17. *Studebaker Camera Car designed by Elemore Morgan Sr.,* 1954, silver gelatin print, 19.5" x 15.75", Collection of The Ogden Museum of Southern Art, UNO
18. *St. Mary's, Wyenoke, LA,* 1958, silver gelatin print, 19.5" x 15.75", Collection of The Ogden Museum of Southern Art, UNO
19. *Men Playing Bouree in the Back of Truck near Pointe À la Hache, LA,* 1948, silver gelatin print, 19.5" x 15.75", Collection of The Ogden Museum of Southern Art, UNO
20. *Trudeau House, near Lutcher, LA,* 1946, silver gelatin print, 19.5" x 15.75", Collection of The Ogden Museum of Southern Art, UNO
21. *Ayres Bros. Store, Anse la Butte,* 1962, silver gelatin print, 19.5" x 15.75", Collection of The Ogden Museum of Southern Art, UNO
22. *Weston Oil Co. Cotton Oil Plant, Natchitoches, LA,* 1949, silver gelatin print, 19.5" x 15.75", Collection of The Ogden Museum of Southern Art, UNO
23. *Gathering Tank Battery, LSU Field,* 1950, silver gelatin print, 19.5" x 15.75", Collection of The Ogden Museum of Southern Art, UNO
24. *Municipal Civic Center, Lafayette, LA, Hays Town, Architect,* 1962, silver gelatin print, 19.5" x 15.75", Collection of The Ogden Museum of Southern Art, UNO
25. *Frank Grace at a Family Wedding, Abbeville, LA,* 1959, silver gelatin print, 19.5" x 15.75", Collection of The Ogden Museum of Southern Art, UNO
26. *Evergreen Plant across from Lutcher, LA, Double Cabin,* 1949, silver gelatin print, 19.5" x 15.75", Collection of The Ogden Museum of Southern Art, UNO
27. *Rural Dance, south of Scott, LA,* 1948, silver gelatin print, 19.5" x 15.75", Collection of The Ogden Museum of Southern Art, UNO
28. *Christy Roberts, Bayou Bethamen, near Bastrop, LA,* 1959, silver gelatin print, 19.5" x 15.75", Collection of The Ogden Museum of Southern Art, UNO
29. *Bird Dogs and Men, E. Fel.,* 1948, silver gelatin print, 19.5" x 15.75", Collection of The Ogden Museum of Southern Art, UNO
30. *Elemore Morgan Sr. in his darkroom, Baton Rouge, LA,* silver gelatin print, 19.5" x 15.75", Collection of The Ogden Museum of Southern Art, UNO
31. *Bocage House near Darrow, LA, Arch 22,* silver gelatin print, 19.5" x 15.75", Collection of The Ogden Museum of Southern Art, UNO
32. *Olin Mill, Huttig Ark.,* 1957, silver gelatin print, 19.5" x 15.75", Collection of The Ogden Museum of Southern Art, UNO
33. *Lides Plantation, Newellton, LA,* 1949, silver gelatin print, 19.5" x 15.75", Collection of The Ogden Museum of Southern Art, UNO
34. *Belle Grove, White Castle, LA,* 1947, silver gelatin print, 19.5" x 15.75", Collection of The Ogden Museum of Southern Art, UNO
35. *Mr. Richardson, Driller, Still on the Job Watching Equipment,* 1952, silver gelatin print, 15.75" x 19.5", Collection of The Ogden Museum of Southern Art, UNO
36. *Baton Rouge Water Co., Water Tank, Perkins Road,* 1947, silver gelatin print, 15.75" x 19.5", Collection of The Ogden Museum of Southern Art, UNO
37. *Magnolia Tree, University Lake, Baton Rouge, LA,* silver gelatin print, 15.75" x 19.5", Collection of The Ogden Museum of Southern Art, UNO
38. *Baton Rouge Water Co., Water Tower, 17th Street,* 1947, silver gelatin print, 15.75" x 19.5", Collection of The Ogden Museum of Southern Art, UNO
39. *St. Amico, S.E. Donaldsonville, LA,* 1947, silver gelatin print, 15.75" x 19.5", Collection of The Ogden Museum of Southern Art, UNO
40. *Smoke Stack, Urania Lumber Co.,* 1953, silver gelatin print, 15.75" x 19.5", Collection of The Ogden Museum of Southern Art, UNO
41. *Long Hot Summer, 3rd Street, Baton Rouge, LA,* 1955, silver gelatin print, 15.75" x 19.5", Collection of The Ogden Museum of Southern Art, UNO
42. *State Mental Hospital, Mandeville, LA, Water Tower,* 1952, silver gelatin print, 15.75" x 19.5", Collection of The Ogden Museum of Southern Art, UNO
43. *Little Zorah Church, New Iberia, LA, Rev. Parker in door,* 1943, silver gelatin print, 15.75" x 19.5", Collection of The Ogden Museum of Southern Art, UNO
44. *M.2, Baton Rouge field,* 1953, silver gelatin print, 15.75" x 19.5", Collection of The Ogden Museum of Southern Art, UNO
45. *Belle Grove Column,* 1949, silver gelatin print, 15.75" x 19.5", Collection of The Ogden Museum of Southern Art, UNO
46. *M.1,* 1953, silver gelatin print, 15.75" x 19.5", Collection of The Ogden Museum of Southern Art, UNO
47. *Remains of Woodlawn, Bayou la Fourche,* 1949, silver gelatin print, 15.75" x 19.5", Collection of The Ogden Museum of Southern Art, UNO
48. *Esso Std. Oil Co., Tanks Storage,* 1950, silver gelatin print, 15.75" x 19.5", Collection of The Ogden Museum of Southern Art, UNO

ELEMORE MORGAN JR.

1. *Luling Bridge,* 1988, acrylic on Masonite, 56" x 47", Collection of Elemore Morgan Jr.
2. *Conversation with Joe Q_____, 2nd LT. USAF, KIA, 1953,* 2005, acrylic on Masonite, 60" x 95", Collection of Elemore Morgan Jr.
3. *Cut Crossing,* 1978, acrylic on Masonite, 32.5" x 66", Collection of Elemore Morgan Jr.
4. *Busy Sky,* 1998, acrylic on Masonite, 6" x 34.5", Collection of Elemore Morgan Jr.
5. *Ocean Front,* 1988, acrylic on Masonite, 6.25" x 38.25", Collection of Elemore Morgan Jr.
6. *Gulf of Mexico,* 2000, acrylic on Masonite, 6" x 47.5", Collection of Elemore Morgan Jr.
7. *Christ Church Meadow,* 1995, acrylic on Masonite diptych, 13.25" x 22.75", Collection of Elemore Morgan Jr.
8. *View of Oxford from Boar's Hill,* 1995, acrylic on Masonite, 6" x 22", Collection of Elemore Morgan Jr.
9. *Standing Female,* 1955, graphite on paper, 22" x 15", Collection of Elemore Morgan Jr.
10. *Seated Female,* 1956, oil on Masonite, 28.5" x 24", Collection of Elemore Morgan Jr.
11. *St. Giles View #1,* 1995, gouache on paper, 12" x 15.5", Collection of Elemore Morgan Jr.
12. *Arida River Bend, Japan,* 1994, gouache on paper, 18" x 24", Collection of Elemore Morgan Jr.
13. *Nave at Kaplan,* 2001, acrylic on Masonite, 59" x 47", Collection of Elemore Morgan Jr.
14. *Rice Field, Koyosan (Japan),* 1994, gouache on paper, 15" x 24", Collection of Elemore Morgan Jr.
15. *Mississippi at St. Francisville,* 2000, gouache on paper, 5.5" x 21.25", Collection of Elemore Morgan Jr.
16. *Industrial Facade,* 1995, acrylic on Masonite, 38.5" x 95", Collection of Elemore Morgan Jr.
17. *View of Canal Structure,* 1971, acrylic on Masonite, 24" x 60", Collection of Elemore Morgan Jr.
18. *Water Source,* 1988, acrylic on Masonite, 26" x 48", Collection of Elemore Morgan Jr.
19. *Rising Cloud,* 1986, acrylic on Masonite, 48" x 19.5", Collection of Elemore Morgan Jr.
20. *Rice Canal Road,* circa 1968, acrylic on Masonite, 23.75" x 23.75", Collection of Elemore Morgan Jr.
21. *Battersea Power Station, London,* 1995, acrylic on Masonite, 12" x 18", Collection of Elemore Morgan Jr.
22. *Three American Studies,* circa 1972 –1974, mixed media on paper, 15" x 10", Collection of Dr. Glenn A. Steen
23. *Control Structure-Clouds,* circa 1969, acrylic on Masonite, 18" x 18", Collection of Janet and Neil Nehrbass
24. *In the Sky,* 2005, acrylic on Masonite, 95" x 47.5", Collection of Faye and Eddie Cazayoux
25. *USA Train Scrolls,* 1983, mixed media on paper (12 parts) 13" x 40" each, Collection of Elemore Morgan Jr.

26. *Torso*, 1956, graphite on paper, 22" x 15", Collection of Elemore Morgan Jr.
27. *View of Baton Rouge*, 1970, acrylic on Masonite, 22" x 48", Collection of Allen Bacqué
28. *Bridge at Morgan City*, 2003, acrylic on Masonite, 25" x 45", Collection of Iberia Bank, Lafayette, LA
29. *Lake Martin view*, 2000, acrylic on Masonite, 64" x 56", Collection of Richard Chachere
30. *Summer Road*, 1980, acrylic on Masonite, 22.25" x 26.5", Collection of the Lafayette Natural History Museum
31. *Ocean View*, 1996, acrylic on Masonite, 22" x 26", Collection of Dr. Whitney and Mrs. Valerie Gonsoulin
32. *Three Panel Mural*, 1952, oil on Masonite, 36" x 288", Collection of the Vermilion Parish Library, Kaplan Branch
33. *Canal Geometry*, 1984, acrylic on Masonite, 26" x 52", Collection of Mr. and Mrs. James Edmunds
34. *North of Rayne*, 2001, acrylic on Masonite, 30.25" x 92.5", Collection of Nancy Tink Adkerson
35. *Summer Still Life*, 2004, acrylic on Masonite, 20" x 47.5", Collection of Mae and Vincent Saia
36. *Kaplan Structures*, 1988, acrylic on Masonite, 40" x 56", Collection of Karen Giger and Larry Eustis
37. *Crescent City*, 2003, acrylic on Masonite, 31" x 122", Collection of Iberia Bank, New Orleans, LA
38. *Rivers Edge*, 2005, acrylic on Masonite, 16" x 95", Collection of Rhett Majoria
39. *From the Porch*, 1999, acrylic on Masonite, 46.75" x 49. 25", Collection of Claire P. Hunter
40. *Winter: Tee Robe Road*, acrylic on Masonite, 18" x 95", Collection of Michael Sartisky, Ph. D.
41. *From Florida*, 2001, gouache on paper, 10" x 12", Collection of Elemore Morgan Jr.
42. *Dead Bird*, 2001, mixed media on museum board, Collection of Elemore Morgan Jr.
43. *Brahma*, 2001, acrylic on Masonite, 39.25" x 80", Collection of Allen Eskew
44. *Wellington Square*, 1958, lithograph, 7.25" x 10", Collection of Elemore Morgan Jr.
45. *Battersea Power Station, London, Sketch*, 1995, mixed media, 7.63" x 22. 5", Collection of Elemore Morgan Jr.
46. *Church in Alabama*, circa 1971, mixed media, 4" x 6", Collection of Elemore Morgan Jr.
47. *Jackson Mississippi*, circa 1971, mixed media, 4" x 6", Collection of Elemore Morgan Jr.
48. *Urban Sprawl, Long Island*, circa 1971, mixed media, 4" x 6", Collection of Elemore Morgan Jr.
49. *Memphis Street Scene*, circa 1972, mixed media, 4" x 6", Collection of Elemore Morgan Jr.
50. *The Form of New York*, circa 1993, mixed media, 7.5" x 21", Collection of Elemore Morgan Jr.
51. *Flying from Memphis to Seattle*, 2002, mixed media, 8.75" x 13", Collection of Elemore Morgan Jr.
52. *House, Maryland*, 1972, mixed media, 4" x 6", Collection of Elemore Morgan Jr.
53. *Making More Suburbs Near Gaithersberg*, 1971, mixed media, 4" x 6", Collection of Elemore Morgan Jr.
54. *View Mesaverde, Pueblo*, 1972, mixed media, 4" x 6", Collection of Elemore Morgan Jr.
55. *Horse Bluff, Utah*, 1972, mixed media, 4" x 6", Collection of Elemore Morgan Jr.
56. *USA Global View*, 1993, pastel and charcoal on paper, 12" x 18", Collection of Elemore Morgan Jr.
57. *Mt. Rainer in the Clouds*, 2003, mixed media, 5.5" x 7", Collection of Elemore Morgan Jr.
58. *San Francisco Bay Bridge*, 1983, pen and ink, 6" x 8.5", Collection of Elemore Morgan Jr.
59. *Near Shiprock, New Mexico*, 1971, graphite on paper, 8.5" x 11", Collection of Elemore Morgan Jr.
60. *Courthouse, Franklin, Tennessee*, circa 1972, mixed media, 4" x 6", Collection of Elemore Morgan Jr.
61. *Sign Buildings, Birmingham, Alabama*, circa 1972, mixed media, 4" x 6", Collection of Elemore Morgan Jr.
62. *St. Louis Arch*, 1972, mixed media, 4" x 6", Collection of Elemore Morgan Jr.
63. *Chapel Hill's Main Street*, circa 1972, mixed media, 4" x 6", Collection of Elemore Morgan Jr.
64. *Thunderstorm, New Mexico*, 1972, mixed media, 4" x 6", Collection of Elemore Morgan Jr.
65. *Cabin-Alabama (near Camden)*, 1972, mixed media, 4" x 6", Collection of Elemore Morgan Jr.
66. *StandardLife, Chicago*, circa 1972, pen on paper, 4" x 6", Collection of Elemore Morgan Jr.
67. *Monument Valley*, 1972, mixed media, 4" x 6", Collection of Elemore Morgan Jr.
68. *San Francisco Drawings*, 1953, pen and ink on paper, 8.25" x 11.25", Collection of Elemore Morgan Jr.
69. *Tang Horse, Kyoto National Museum, and Armed Deity, 12ᵗʰ Century, Hein*, 1994, graphite on paper, 7" x 10", Collection of Elemore Morgan Jr.
70. *Judges in Hell, Yamaraja, 13ᵗʰ Century, Kyoto National Museum*, 1994, graphite on paper, 8" x 22", Collection of Elemore Morgan Jr.
71. *Sagano, Japan*, 1994, gouache on paper, 4" x 6", Collection of Elemore Morgan Jr.
72. *Two Drawings of Kabuki Theatre Performance, Tokyo*, 1994, mixed media, 6" x 8.5", Collection of Elemore Morgan Jr.
73. *Photograph of Elemore Morgan Jr. (left) with another USAF Officer, Korea*, 1953, color photograph, 5" x 7", Collection of Elemore Morgan Jr.
74. *Boxers*, 1948, graphite on paper, 9" x 12", Collection of Elemore Morgan Jr.
75. *Banzai*, circa 1944, graphite on paper, 9" x 12", Collection of Elemore Morgan Jr.

76. *Hand to Hand Combat*, circa 1944, graphite on paper, 9" x 11.75", Collection of Elemore Morgan Jr.
77. *Design Study, LSU*, Circa 1950, caesin on paper, 6" x 9.25" Collection of Elemore Morgan Jr.
78. *Black Figure*, circa 1951, wood engraving, 4" x 5", Collection of Elemore Morgan Jr.
79. *In the Beginning*, circa 1951, wood engraving, 4" x 5", Collection of Elemore Morgan Jr.
80. *Musician, Henry Butler*, 2004, graphite on paper, 8" x 10.5", Collection of Elemore Morgan Jr.
81. *Dickie Landry*, 2004, pen and ink on paper, 5.5" x 7.25", Collection of Elemore Morgan Jr.
82. *Luling Bridge*, 2001, graphite on paper, 7.5" x 22", Collection of Elemore Morgan Jr.
83. *Keith Frank and his band, Breaux Bridge Crawfish Festival*, 2003, gouache on paper, 11" x 30", Collection of Elemore Morgan Jr.
84. *Performer, Judy Carmichael*, 2002, pen and ink on paper, 6.25" x 9", Collection of Elemore Morgan Jr.
85. *Cezanne's Mountain*, 1956, gouache on paper, 10" x 13.75", Collection of Elemore Morgan Jr.
86. *Mt. Tabor*, 1956, gouache on paper, 9.88" x 13.5", Collection of Elemore Morgan Jr.
87. *Erectheum*, 1956, gouache on paper, 8.5" x 13", Collection of Elemore Morgan Jr.
88. *Sea of Galalee*, 1956, gouache on paper, 9.5" x 13", Collection of Elemore Morgan Jr.
89. *Golan Heights*, 1956, gouache on paper, 9.63" x 13.25", Collection of Elemore Morgan Jr.
90. *Acropolis: Parthenon*, 1956, gouache on paper, 9.5" x 13", Collection of Elemore Morgan Jr.
91. *Study for a Painting*, circa 1944, graphite on paper, 12" x 18", Collection of Elemore Morgan Jr.
92. *Man Carrying Something*, silkscreen on paper, 19" x 10", Collection of Elemore Morgan Jr.
93. *When Johnny Comes Marching Home Again*, 1952, lithograph, 12" x 17", Collection of Elemore Morgan Jr.
94. *Color and Design Studies, LSU*, 1950, casein on paper, 14" x 17", Collection of Elemore Morgan Jr.
95. *Self-Portrait (Oxford)*, 1955, self-timed b&w photograph, 4" x 6", Collection of Elemore Morgan Jr.
96. *John Updike (Oxford)*, 1955, b&w photograph, 4" x 6", Collection of Elemore Morgan Jr.
97. *London Bobbies*, circa 1955, b&w photograph, 4" x 6", Collection of Elemore Morgan Jr.
98. *Regent Street*, circa 1955, b&w photograph, 4" x 6", Collection of Elemore Morgan Jr.
99. *Wellington Square*, 1955, b&w photograph, 8" x 10", Collection of Elemore Morgan Jr.
100. *People, London*, 1955, b&w photograph, 4" x 6", Collection of Elemore Morgan Jr.
101. *Angouleme, France, Street Scene*, circa 1956, b&w photograph, 4" x 6", Collection of Elemore Morgan Jr.
102. *Angouleme, France, Parapet Wall*, circa 1956, b&w photograph, 4" x 6", Collection of Elemore Morgan Jr.
103. *Jericho Playground (Oxford)*, 1955, b&w photograph, 10" x 18", Collection of Elemore Morgan Jr.
104. *Great Clarendon Street (Oxford)*, 1955, b&w photograph, 10" x 18", Collection of Elemore Morgan Jr.
105. *Into the Forest*, 1950, casein on board, 8" x 15", Collection of the Louisiana Division of the Arts
106. *Four Drawings of Zydeco Musicians, LA Crossroads*, 2002-03, ink wash on paper, 5" x 8" each, Collection of Elemore Morgan Jr.
107. *Flamenco Dancers, PASA Performance*, 2003, pen and ink, 5.5 x 25 inches Collection of Elemore Morgan Jr.
108. *Sonny with Jerry Douglas, Angelle Hall, UL*, 2001, pen and ink, 6" x 18", Collection of Elemore Morgan Jr.
109. *Cow Studies*, 2000, ink wash on paper, 9" x 24", Collection of Elemore Morgan Jr.
110. *Traffic Barriers*, 1950, oil on canvas, 10" x 18" Collection of Elemore Morgan Jr.

ELEMORE M. MORGAN SR.

Born October 22, 1903, Baton Rouge, LA
Died April 10, 1966

EDUCATION
Baton Rouge High School, Baton Rouge, LA
Louisiana State University

SOLO EXHIBITIONS
1968 Baton Rouge Gallery, Baton Rouge, LA
1969 University of Southwestern Louisiana, Lafayette, LA
1992 *Photographs by Elemore Morgan: Rural Life and Landmarks in Louisiana, 1937-1965*, Retrospective exhibition organized and shown at Alexandria Museum of Art, Alexandria, LA. Traveled to Imperial Calcasieu Museum, Lake Charles, LA, Arts and Science Center, Baton Rouge, and University Art Museum, University of Louisiana at Lafayette, Lafayette, LA

OTHER SOLO EXHIBITIONS
Louisiana State Art Commission Galleries, Old State Capitol, Baton Rouge, LA
Tulane University, New Orleans, LA
Michigan State University, East Lansing, MI
Louisiana State University, Baton Rouge, LA
Texas A&M College, College Station, TX
Mississippi Photographic Society, Jackson, MS
Southern University, Baton Rouge, LA
Lafayette Art Museum, Lafayette, LA
Vermilion Parish Library, Abbeville, LA

GROUP EXHIBITIONS
1976 *Louisiana Bien Aimee*, Radio France Building, Paris, France
 U.S. Bicentennial exhibition organized jointly by the State of Louisiana and Radio France. Following the exhibition, all Morgan's photographs, numbering more than forty, were donated to the University of Southwestern Louisiana and are now on display in Dupre Library
 1776-1796: 200 Years of Life and Change in Louisiana, Lafayette Museum of Natural History, Lafayette, LA
1980 *Photography in Louisiana: 1900-1980*, New Orleans Museum of Art, New Orleans, LA
 Louisiana Images, Broussard Memorial Galleries, Louisiana Division of the Arts, Baton Rouge, LA
1981 Natchitoches Folk Festival Timber Exhibit, Northwestern State University, Natchitoches, LA
1986 *A Century of Vision Louisiana Photography 1884-1984*, University Art Museum, University of Southwestern Louisiana, Lafayette, LA
1990 *Folklife in Louisiana Photography: Images of Tradition*, Louisiana State University Union Gallery, Baton Rouge, Louisiana State Museum, New Orleans, LA, Louisiana State Exhibit Museum, Shreveport, LA
1991 Exhibits on the history and culture of Cajun people, Jean Lafitte National Historic Park at sites in Eunice, Lafayette and Thibodaux, LA

2002 *Then and Now*, group exhibition at the Ogden Museum of Southern Art, UNO, New Orleans, LA
2003 *The Story of the South 1890-2003*, The Ogden Museum of Southern Art, UNO, New Orleans, LA
2004 *Eudora Welty, Clarence Laughlin and Elemore Morgan Sr.: Works from the Permanent Collection*, The Ogden Museum of Southern Art, UNO New Orleans, LA

HONORS AND AWARDS
1994 Preservation Award, posthumously awarded by the Foundation for Historical Louisiana
1995 The Baton Rouge Historic Foundation Award
2001 James William Rivers Prize in Louisiana Studies, co-recipient with Elemore Morgan Jr., awarded by the Center for Louisiana Studies, University of Louisiana at Lafayette, Lafayette, LA

COLLECTIONS
The Ogden Museum of Southern Art, UNO, New Orleans, LA
The Historic New Orleans Collection, New Orleans, LA
New Orleans Museum of Art, New Orleans, LA
The Louisiana State Library, Baton Rouge, LA
Jean Lafitte National Historic Park, New Orleans, LA
Louisiana State University Rural Life Museum, Baton Rouge, LA
Louisiana State University, Baton Rouge, LA
Lafayette Natural History Museum, Lafayette, LA
University Art Museum, University of Southwestern Louisiana, Lafayette, LA
Dupree Library, University of Southwestern Louisiana, Lafayette, LA
Alexandria Museum of Art, Alexandria, LA

SELECTED BIBLIOGRAPHY
Alexandria Museum of Art, *Photographs by Elemore Morgan: Rural Life and Landmarks in Louisiana, 1937-1965*. Alexandria, Louisiana: Alexandria Museum of Art, 1992.

Black, Meme. *Tramp Steamers*. Reading, MA: Addison, 1981.

Carter, Hodding. *John Law Wasn't So Wrong*. Baton Rouge: Esso Standard Oil Company, 1952,

de Caro, Frank. *Folklife in Louisiana Photography: Image and Tradition*. Baton Rouge: LSU Press, 1991.

East, Charles. *The Face of Louisiana*. Baton Rouge: Louisiana State University Press, 1969.

Gruber, J. Richard and Houston, David. The Ogden Museum of Southern Art, UNO. *The Story of the South 1890-2003 The Ogden Museum of Southern Art, UNO*. London: Scala Publishers, 2004.

Kane, Harnett T. *The Bayous of Louisiana*. New York: William Morrow and Company, 1943.

Kerr, Ed. *The Lower Mississippi Valley*. Baton Rouge: Claitor's Bookstore, 1962.
Keyes, Frances Parkinson. *All This is Louisiana*. New York: Harper and Brothers, 1950.

Kniffen, Fred R. *Louisiana, Its Land and People*. Baton Rouge: Louisiana State University Press, 1968.

Lafayette Museum of Natural History. *1776-1976: 200 Years of Life and Change in Louisiana*. Lafayette, Louisiana: Lafayette Museum of Natural History, 1976.

Mhire, Herman. *A Century of Vision: Louisiana Photography 1884-1984*. Lafayette, Louisiana: University of Southwestern Louisiana, 1986.

Morgan, Elemore Sr. *The Sixties Ended It*. Baton Rouge: Helen and Melvin Shortess, 1960.

Morgan, Elemore, and Kerr, Ed. *5 Days in Baton Rouge*. Baton Rouge: Henry Louis Cohn, 1952.

Rushton, William Faulkner. *The Cajuns, from Acadia to Louisiana*. New York: Farrar Straus Giroux, 1979.

Rutt, Anna Hong. The *Art of Flower and Foliage Arrangement*. New York: Macmillan, 1958.

Spitzer, Nicholas. *Louisiana Folklife*. Baton Rouge: Louisiana Office of Tourism, 1985.

ELEMORE M. MORGAN JR.

Born August 6, 1931, Baton Rouge, LA

EDUCATION
1952 B.A. in Fine Arts, Louisiana State University, Baton Rouge, LA
1957 C.F.A. Ruskin School of Fine Arts, University of Oxford, England

SELECTED HONORS
1952 Phi Kappa Phi, Louisiana State University
1984 Outstanding Undergraduate Teaching Award presented
 by Amoco Foundation
1985 Distinguished Professor Award presented by University of
 Southwestern Louisiana
1990 Outstanding Achievement in the Arts Award presented by Acadiana
 Arts Council, Lafayette, LA
1994 Two week travel grant to Japan sponsored by Japan Foundation under
 short term visitors program

PROFESSIONAL APPOINTMENTS
1952-1954 1st Lt., US Air Force
1965-1998 Professor of Visual Arts, University of Louisiana at Lafayette, LA,
 retired 1998

SELECTED SOLO EXHIBITIONS
1957 Lafayette Museum, Lafayette, LA
1971 Lafayette Natural History Museum, Lafayette, LA
1982 *Elemore Morgan Jr. Paintings, Drawings, Photographs, 1953-81*,
 retrospective exhibition, Lafayette Natural History Museum,
 Lafayette, LA
1984 *Art Works 84*, Louisiana World Exposition, New Orleans, LA
1985, 1989, 1992, 1995, 1998, 2001, 2003, 2005
 Arthur Roger Gallery, New Orleans, LA
1986 The Swain School of Design, New Bedford, Massachusetts
1992 *From the Artist's Collection, A Retrospective Exhibition of Landscape Paintings
 and Drawings*, Clark Hall Gallery, Southeastern Louisiana University,
 Hammond, LA
1994 *Elemore Morgan Jr.: Paintings and Drawings*, Abercrombie Gallery,
 McNeese State University, Lake Charles, LA
1995 *Elemore Morgan Jr.: A Survey of Work from the Past Twenty Years*,
 Southside Gallery, Oxford, MS
1999-2001 *Where Land Meets Sky: Paintings and Drawings by Elemore Morgan Jr.*,
 retrospective exhibition, University Art Museum, University of
 Southwestern Louisiana, Lafayette, LA, Southeastern Louisiana
 University, Hammond, LA
2003 *The Story of the South-Art and Culture 1890-2003*, inaugural exhibition,
 The Ogden Museum of Southern Art, UNO, New Orleans, LA

SELECTED GROUP EXHIBITIONS
1955 *Young Contemporaries Exhibition*, juried exhibition, London, England
 (Traveling Exhibition arranged by the Arts Council of Great Britain)
1976 *Bicentennial Exhibition on Louisiana*, jointly sponsored by the Council
 for the Development of French in Louisiana and Radio France, Radio
 France Building, Paris, France
1979 Galerie Quebec, Paris (group show of three Louisiana painters)
 Invitational Exhibition of ten Louisiana artists, Old State Capital
 Galleries, Baton Rouge, LA
1980 *New Louisiana Landscape*, Contemporary Arts Center, New Orleans, LA
 Arcus Cultural Center, Paris (group exhibition of Louisiana artists)
 Louisiana Major Works," juried exhibition curated by Linda Cathcart,
 Contemporary Arts Center, New Orleans, LA
1984 *The Fertile Crescent*, exhibition of Louisiana Artists, supported by the
 Southern Arts Federation (tour of museums of the Southern
 United States)
1985 *The Exhibition*, Arthur Roger Gallery, Exhibition Space Gallery,
 New York, NY
1986 *Landscape, Seascape, Cityscape*, invitational group exhibition,
 Contemporary Arts Center, New Orleans, Louisiana, and New York
 Academy of Design, New York, NY
1987 *Vistas: Approaches to Panoramic Landscape*, curated by Peter Frank, G.W.
 Einstein Gallery, New York, NY
1991 *Inaugural Exhibition*, Arthur Roger Gallery, New York, NY
1993 *Art in the American South*, selected works from Roger Houston Ogden
 Collection, University Art Museum, University of Southwestern
 Louisiana, Lafayette, LA
 Inaugural Exhibition, Morris Museum of Art, Augusta, GA
1996 *20th Anniversary Exhibition*, Contemporary Arts Center,
 New Orleans, LA
1999 *Outward Bound: American Art at the Brink of the Twenty-first Century*,
 invitational exhibition of seventy-eight American artists organized
 by Meridian International Center and White-Meyer Galleries,
 Washington, D.C.; six city tour of Southeast Asia
2000 *Treasure Houses: Louisiana Museums for A New Millennium*, selected
 works from Louisiana museums and collections, Louisiana Arts and
 Science Center, Baton Rouge, LA
2002 *Then and Now*, group exhibition at The Ogden Museum of Southern
 Art, UNO, New Orleans, LA
2003 *The Story of the South 1890-2003*, The Ogden Museum of Southern Art,
 UNO, New Orleans, LA
2004 *Spirit of Place: Art From Acadiana*, Acadiana Arts Center, Lafayette, LA
2005 *Spirit of Place: Art From Acadiana*, The Ogden Museum of Southern Art,
 UNO, New Orleans, LA

COLLECTIONS
Numerous private collections as well as The Grand Hotel, Paris, France; Morris
Museum of Art, Augusta, GA; New Orleans Museum of Art; Roger Houston Ogden
Collection, New Orleans, LA; Lafayette Natural History Museum, University Art
Museum, Lafayette, LA; Atlantic Richfield Company, Los Angeles, CA; the State of
Louisiana; City National Bank, Baton Rouge, LA; Aquarium of Americas, Bank One,
Pan American Life Center, Westminster Corporation, New Orleans, LA; Guaranty
Deposit Bank, Natchez, MS, The Ogden Museum of Southern Art, UNO,
New Orleans, LA

COLLECTIONS OF PHOTOGRAPHS
Private collections as well as The Smithsonian Institute, Washington, D.C.; New
Orleans Museum of Art, New Orleans, Louisiana; Lafayette Natural History Museum,
Lafayette, Louisiana, University Art Museum, University of Louisiana at Lafayette,
Louisiana; Permanent exhibits at Jean Lafitte National Park and Preserve Acadian
Cultural Centers in Eunice, Lafayette and Thibodeaux, Louisiana

SELECTED COMMISSIONED WORKS
1964 Mosaic Arch, lobby of former Chancery Building, now office of
 Catholic Diocese of Lafayette, LA
1986 Four panel mural scale paintings and four small mixed media drawings
 executed for lobby of Saratoga Oil and Gas building, New Orleans, LA
1993 Executed two panel mural *Liveoak Rice Cycle*, lobby of corporate
 headquarters, Riviana Foods, Inc., Houston, TX
1996 Painting *Summer Afternoon* reproduced in color on cover of special
 limited edition of James Lee Burke's book *Cadillac Jukebox*, B. E. Trice
 Publishing, New Orleans, LA
2003 *View from the Prairie*, reproduced on inaugural poster, The Ogden
 Museum of Southern Art, UNO, New Orleans, LA

PHOTOGRAPHY AND PUBLICATIONS
1979 *The Cajuns* by William Rushton
1983 *The Cajuns: Essays on Their History and Culture*, Glen Conrad, editor
 Photographs in a brochure published by Smithsonian Institute and
 National Park Service for Festival of American Folklife
1984 Color photographs in *The Makers of Cajun Music*, documentary study
 of Cajun music, text by Barry Ancelet, University of Texas Press;
 reviews in over fifty newspapers and magazines including *The New York
 Times* and *Publisher's Weekly*; designated an Honor Book by Louisiana
 Library Association
1988 *The French Americans*, text by Polly Morrice
 Black and white photograph used on poster produced by American
 Folklife Center, Library of Congress, to commemorate Centennial of
 the American Folklore Society
1989 *Louisiana: A Geography*, Abington, Bullamore and Johnson
1991 *Folklife in Louisiana Photography: Images of Tradition*, text by Frank de
 Caro, LSU Press

| 1992 | Color slides of rice growing region of Southwestern Louisiana used as rear screen projections in *Gumbo Ya Ya* |
| 1996 | Five color photographs of Cajun musicians, front and back of CD cover, *Cajun and Creole Masters*, Music of the World and World Music Institute |

PHOTOGRAHY EXHIBITIONS

1980	*Photography in Louisiana, 1900-1980*, New Orleans Museum of Art, New Orleans, LA
1986	*A Century of Vision: Louisiana Photography, 1884-1984*, Louisiana State Museum-Presbytere, New Orleans, Louisiana; University Art Museum, University of Southwestern Louisiana, Lafayette, LA
1988	*New Orleans Photography Biennial Exhibition*, invitational group exhibition, Downtown Gallery, New Orleans, LA
1991-1995	*Dedans Le Sud de la Louisiane*, invitational three man exhibition organized by University Art Museum, University of Southwestern Louisiana, toured France, Belgium and Canada

SELECTED BIBLIOGRAPHY

Clark Hall Gallery. *From the Artist's Collection, A Retrospective Exhibition of Landscape Paintings and Drawings*. Hammond, Louisiana: Southeastern Louisiana University, 1992.

Contemporary Arts Center. *Louisiana Major Works*. New Orleans: Contemporary Arts Center, 1980.

Contemporary Arts Center. *Landscape, Seascape, Cityscape*. New Orleans: Contemporary Arts Center, 1986.

Lafaye, Bryan, ed. *Where Land Meets Sky: Paintings and Drawings by Elemore Morgan Jr.* Lafayette, Louisiana: University Art Museum, University of Southwestern Louisiana, 1999.

Lafayette Natural History Museum. *Elemore Morgan Jr. Paintings, Drawings, Photographs, 1953-81*. Lafayette, Louisiana: Lafayette Natural History Museum Association, 1982.

Morris Museum of Art. *Inaugural Exhibition*. Augusta, Georgia: Morris Museum of Art, 1993.

The Ogden Museum of Southern Art. *The Story of the South 1890-2003*. London: Scala Press, 2004.

Roger, Arthur, ed. New Orleans: Arthur Roger Gallery, 1998.

Roger, Arthur, ed. The Exhibition. New York: Arthur Roger Gallery, 1985.

University Art Museum. *Art in the American South*. Lafayette, Louisiana: University of Southwestern Louisiana, 1993.

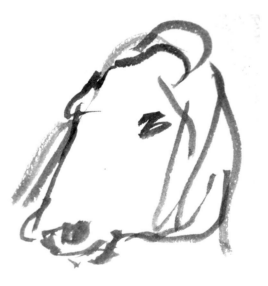

Cow from sketchbook
Collection of Elemore Morgan Jr.

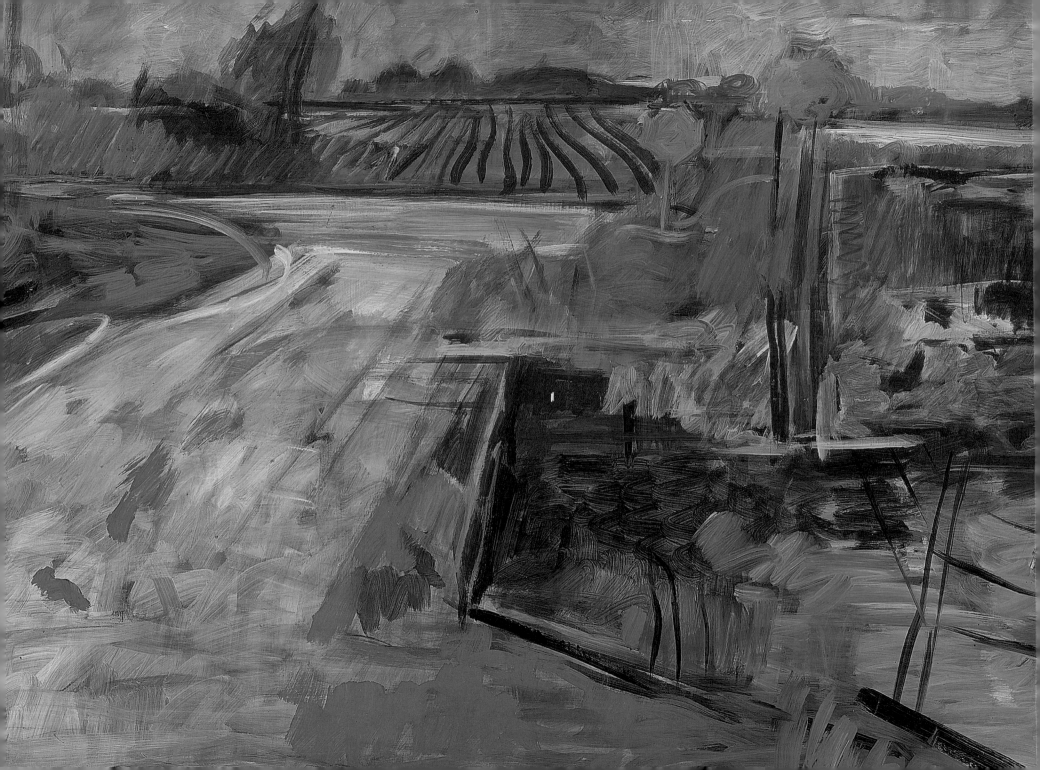